THE BLACK FROG'S
DOODLES
you know...teapots and stuff

**200
5-minute
doodles**

Art Direction: Marsha Stevenson
Layout Production: Marsha Stevenson
Text Editor: Kevin Brown

Published by Design Studio Press
8577 Higuera Street
Culver City, CA 90232
Web site: www.designstudiopress.com
E-mail: info@designstudiopress.com

10 9 8 7 6 5 4 3 2 1

Printed in China
First Edition, December 2006

ISBN-13 978-1-933492-22-3
ISBN-10 1-933492-22-8
Library of Congress Control Number:
2006929570

TABLE OF CONTENTS

ABOUT THE ARTIST

Teapots, monsters, silly robots, and other weird characters and concepts. Each of them doodled in five minutes: on the side of a shelf during a phone conversation; on a napkin at a restaurant or while having a cup of coffee at Jaxx on Sunset Blvd.

Igor-Alban Chevalier—AKA, The Black Frog—was born in Champagne, France in 1973. The only son of an antique dealer/art teacher, Chevalier spent his childhood surrounded by antiques—traveling in the back of a truck going from one antique fair to another, comfortably cocooned in a little space between furniture and paintings.

All he did in his early days was invent mad-scientist laboratories from cardboard boxes, design fake IDs for his "Special Agent" fluffy toys, play Lego until dawn and read European comic books…a lot of them!

It was at that time that he discovered the work of glorious comic book artists like Liberatore, Moebius, and Frank Miller… and decided that his dreams of becoming a clown were over. From that day on, all he wanted to do was draw.

Since then Igor jumped from one country to another: doing design for games at first; and staying at Jim Henson's Creature Shop in London for four years where he started his career in the cinema industry, sculpting and designing critters for movies like *Harry Potter and the Sorcerer's Stone* and *X-Men 3*.

He now freelances in Los Angeles as a visual-effects art director.

If you want to know more about the art of The Black Frog visit his website:
WWW.DYNAMOGRAFIKA.COM

FOREWORD

Volumes would be required to give a full account of Igor's madness. So let's just say that he's a lunatic. I first arrived at this conclusion ten years ago, about four seconds after I first met him in London. I'm sure it wasn't just the foppish dress—a *fin de siecle* cross between a taller Toulouse Lautrec and Captain Nemo, or his cousin, the balloonist—no, I've always had a nose for lunacy, and I could smell it. He was nuts.

As it so happens I have a fatal allergy to nuts, but to his kind I have an ever-pressing need for more. And more means blowing every *centime*, pence, and penny on the obsolescent items of a lost world: watch fobs, top hats, button braces, spats, traveling trunks, green-glass bottles, gas-masks, steam toy boats, aviator's goggles, foils, picnic phonographs and—should it now come as a surprise that he lives in LA-LA Land and still refuses to get a car? Or even learn to bloody drive! "Why no sir", he would say, "I'm waiting for my *Bugatti*."

But this is nothing.

Igor's favorite pastime is to make elaborate games that no one will play. Elaborate board games, see, with little leaden pieces and—need I say more?

But there is more.

His little scribblings have gone on to build whole universes over breakfast—and yet he cannot work without five witnesses applauding rapturously behind him.

Must I speak of his obsession with the cow, and iron rivets, and coffee spoons—he keeps a dozen spoons inside his pockets at all times—*at all times!*—but no, I can't.

Monsieur Le Black Frog lives not in our world but in his own cerebral, underground city. I've seen his room—a bed of cardboard, walls of cork and putty, stovepipe ceilings, sawdust floors…but *mirrors*, I could not find one. As sure as I know Igor as a madman, he would sooner draw his future and himself a cartoon in it, than to take what stands before him as the truth. *La Grenouille Noire*!

And now I'm asked to write a preface to this little book of sketches—is that all, one inch of stovepipe in his brain? "*Two Hundred 5-Minute Doodles*" is what they tell me—I'm not surprised. Think nothing of it. This is peanuts! Toothpaste spit! He probably did it on a dare.

S. Anonymous
—NYC—

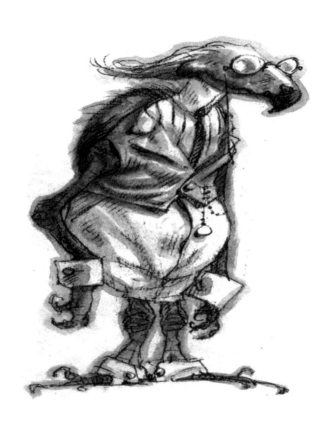

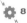 8

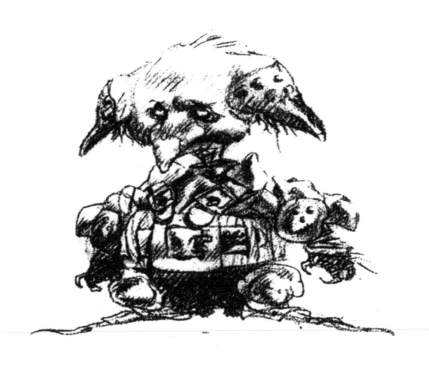

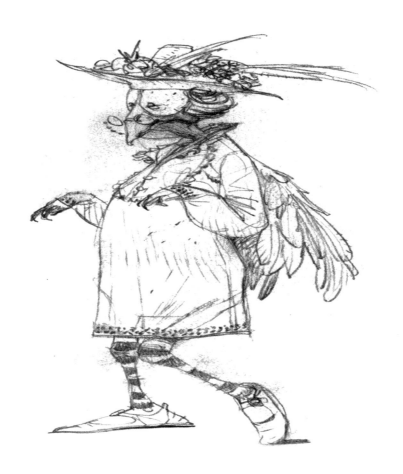

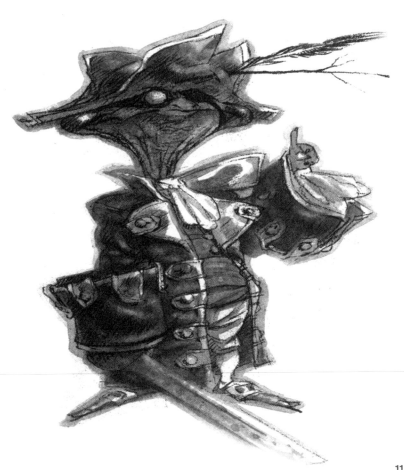

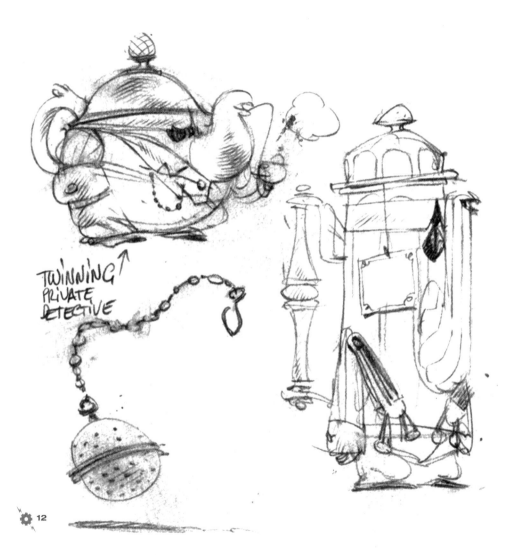

TWINNING
PRIVATE
DETECTIVE

12

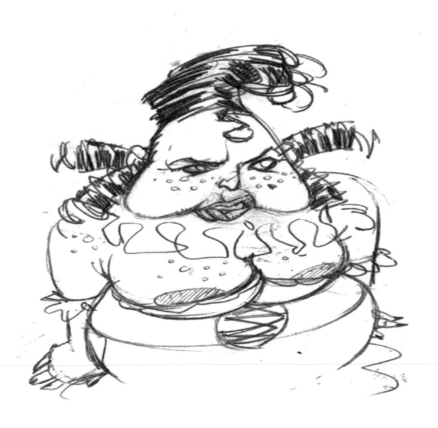

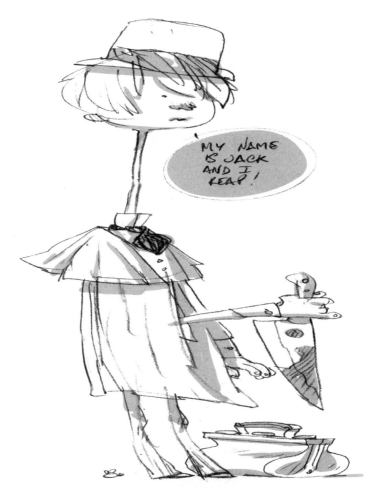

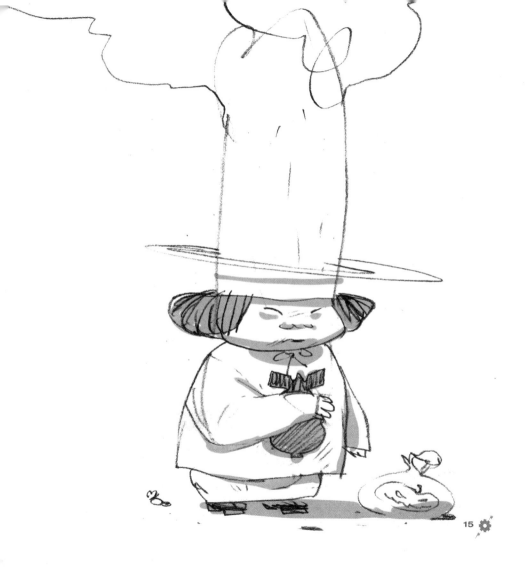

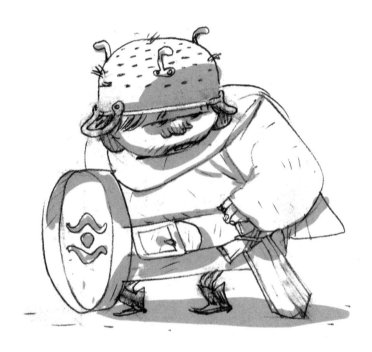

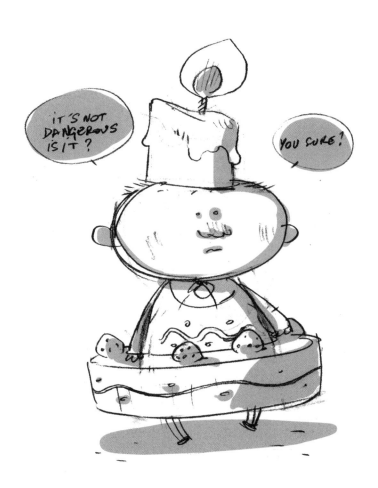

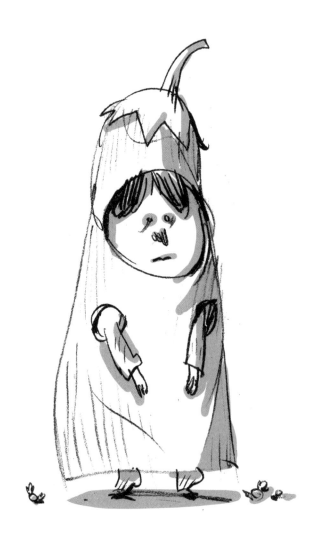

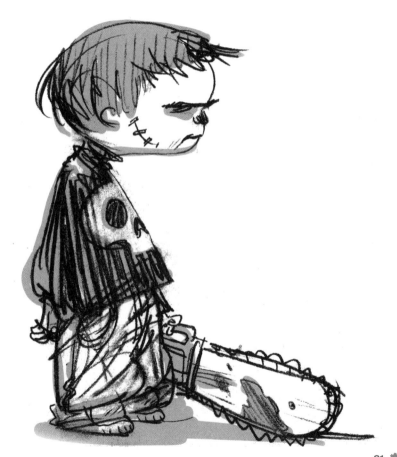

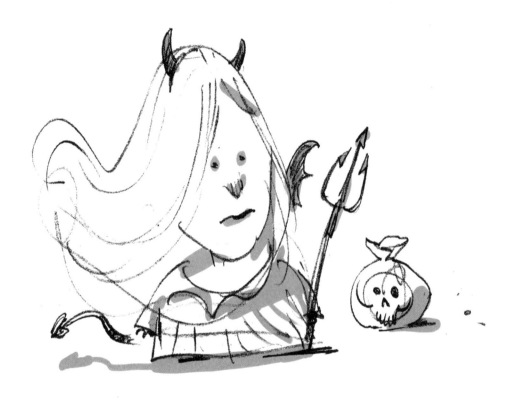

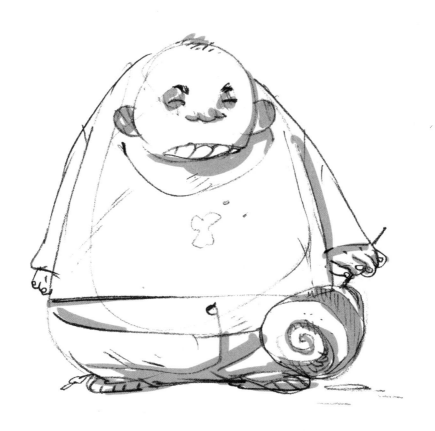

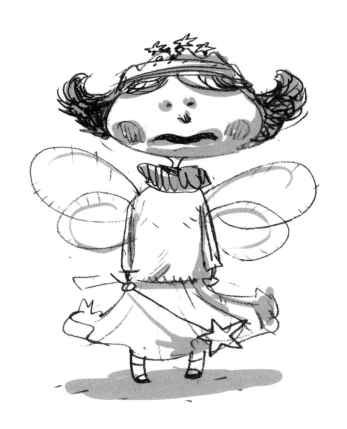

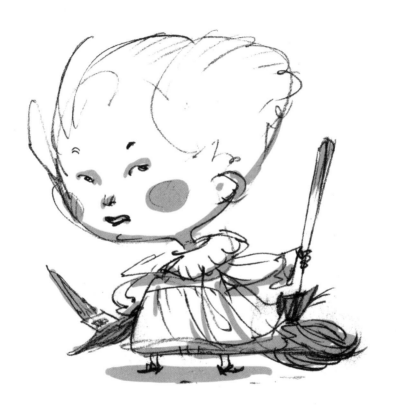

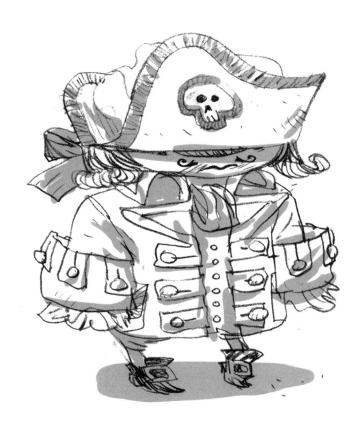

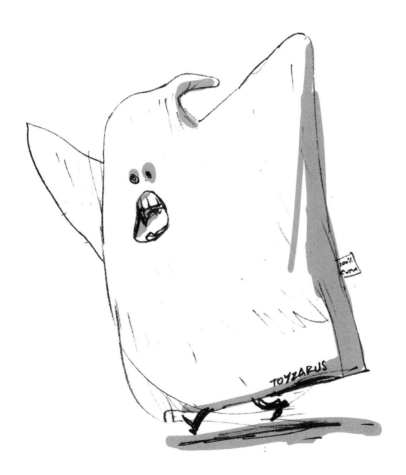

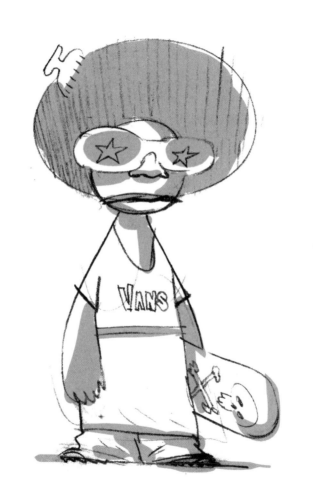

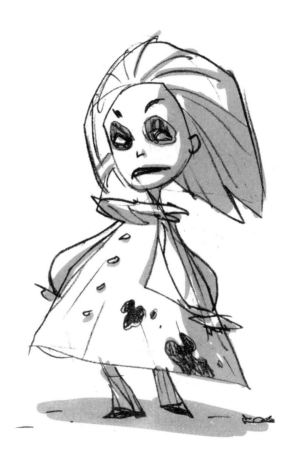

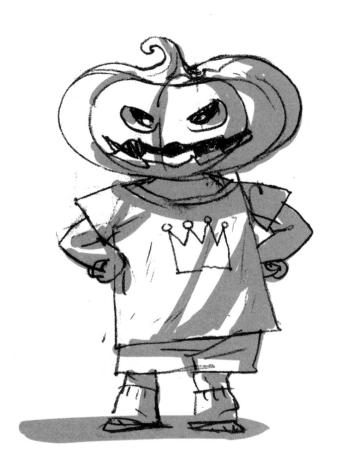

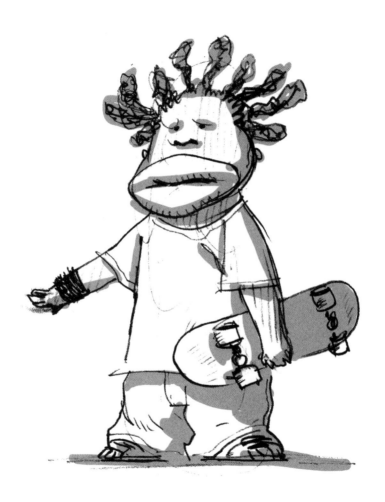

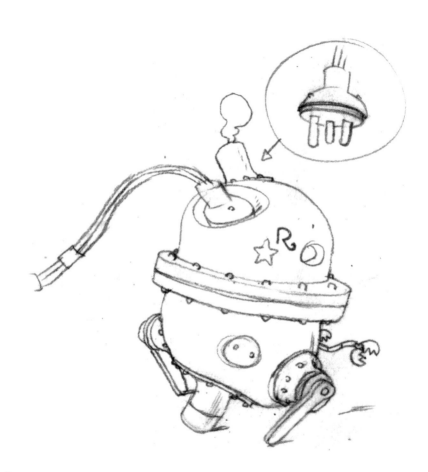

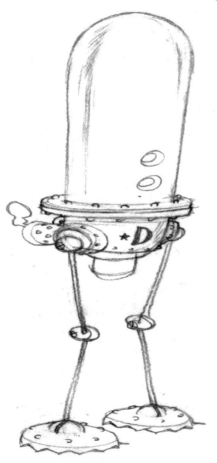

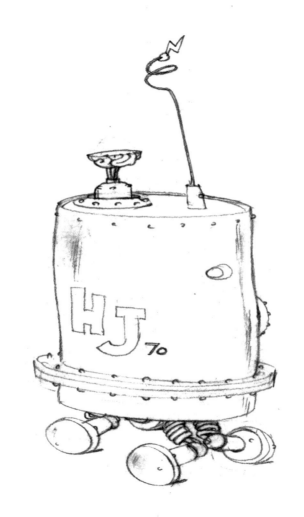

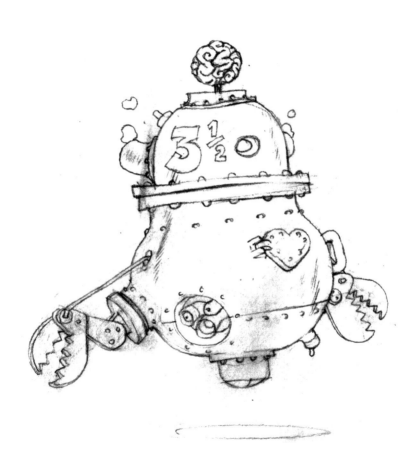

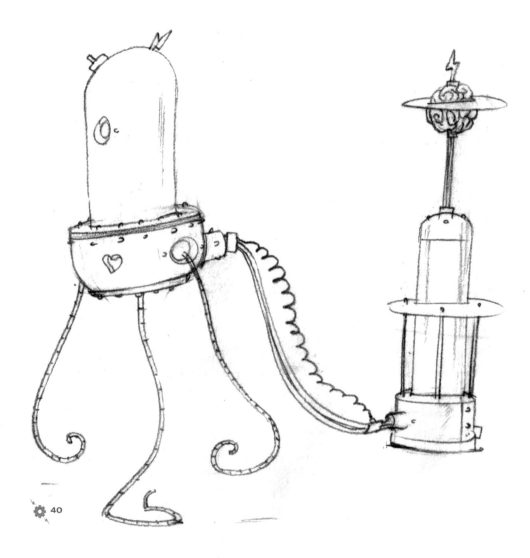

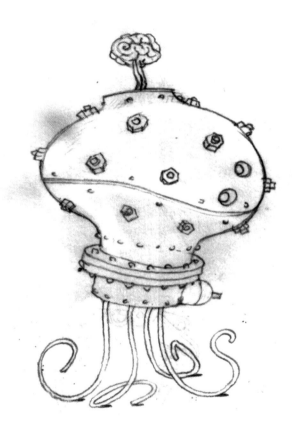

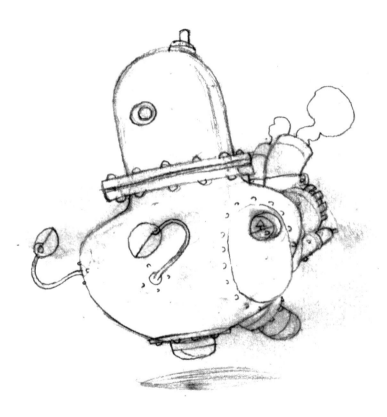

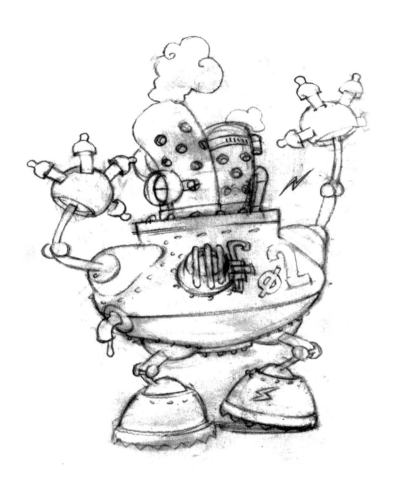

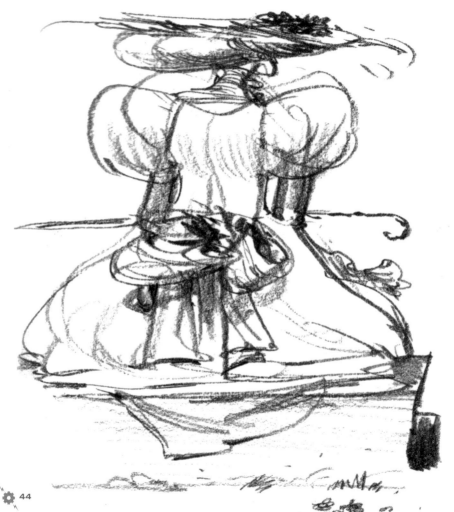

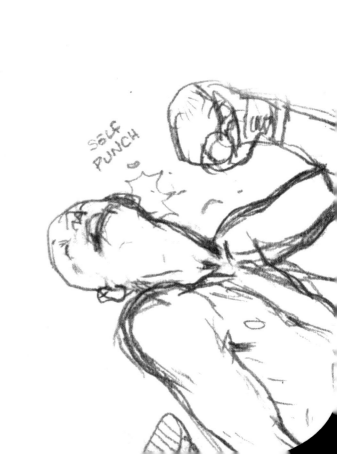

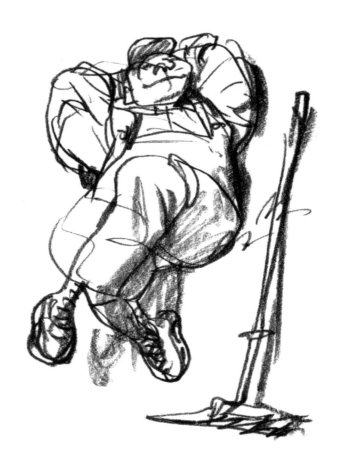

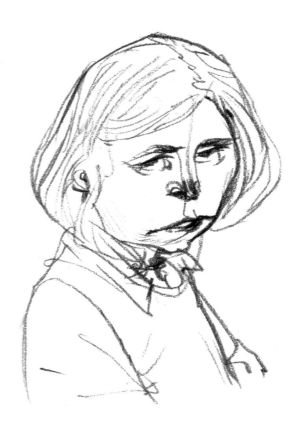

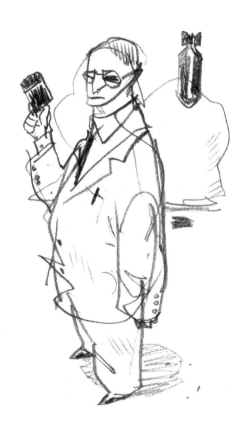

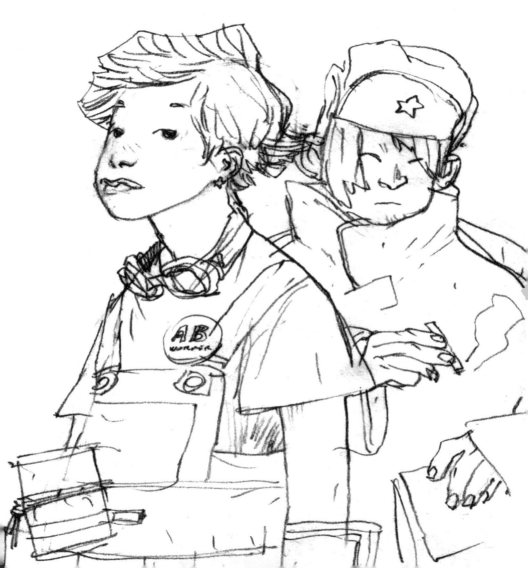

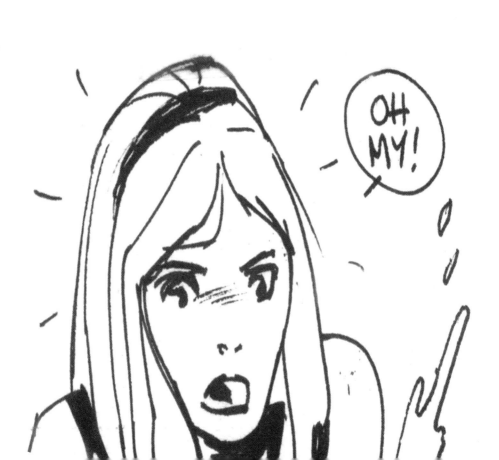

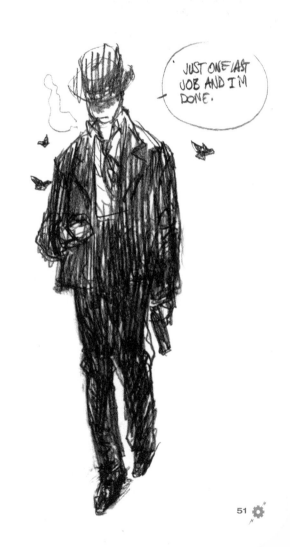

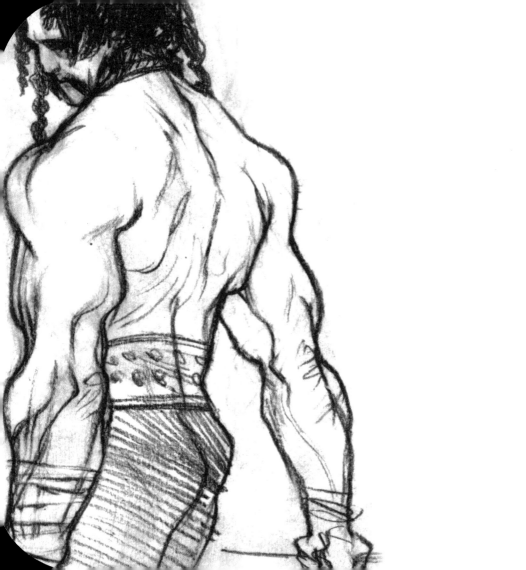

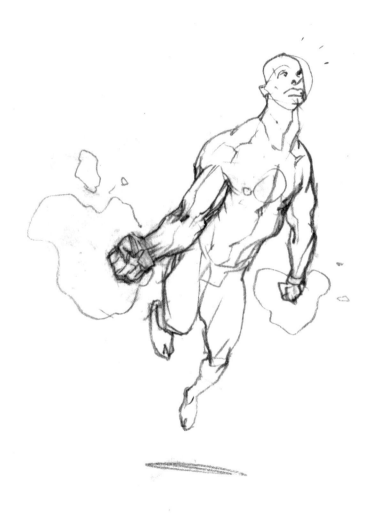

53 ⚙

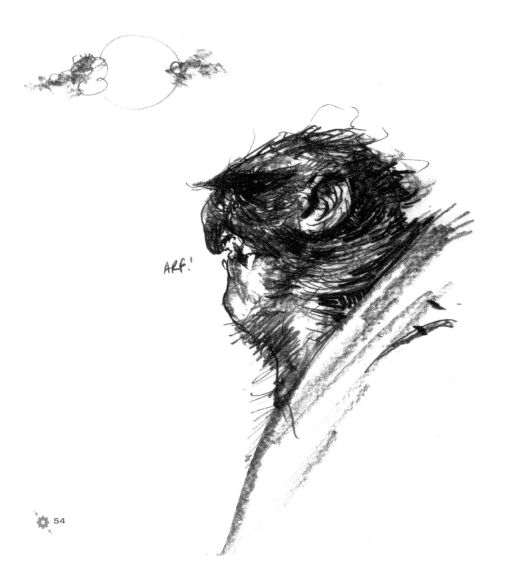

ARF!

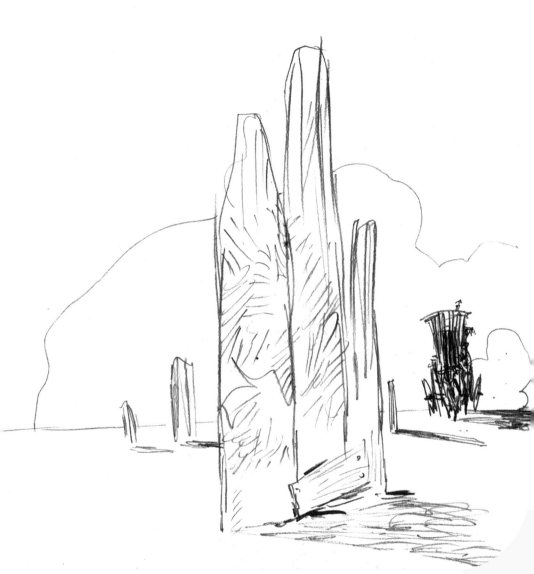

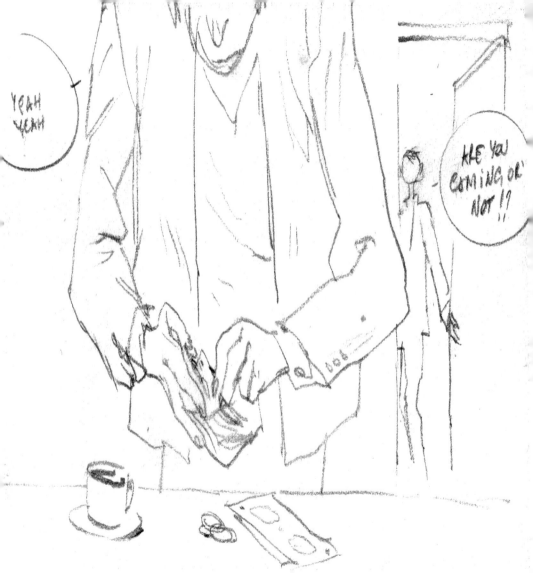

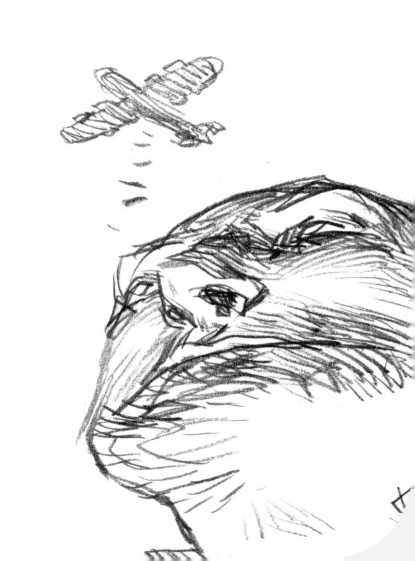

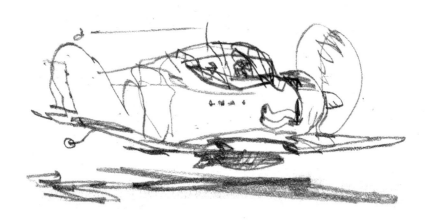

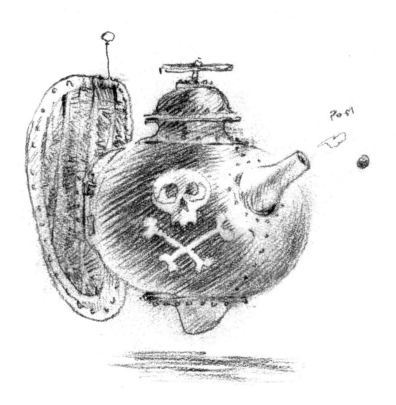

Port

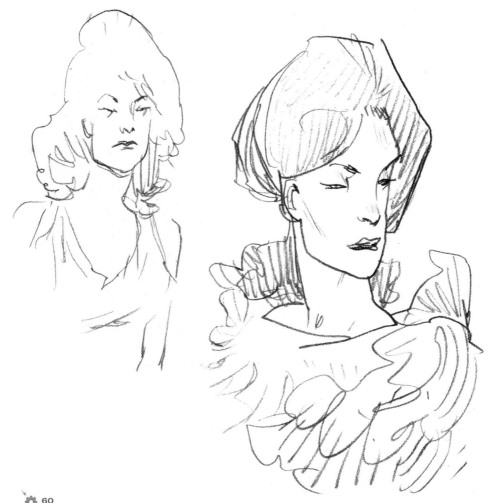

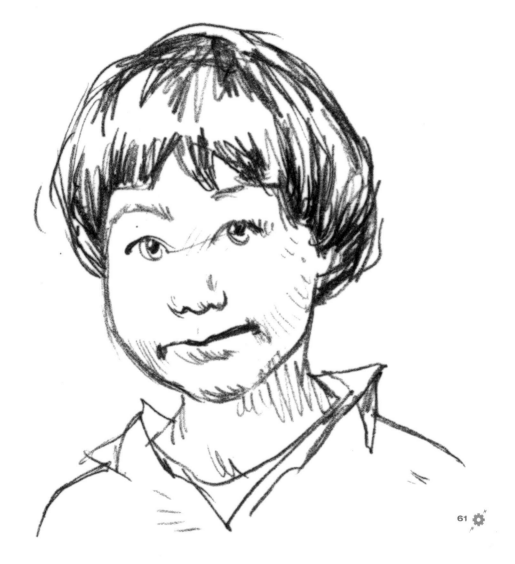

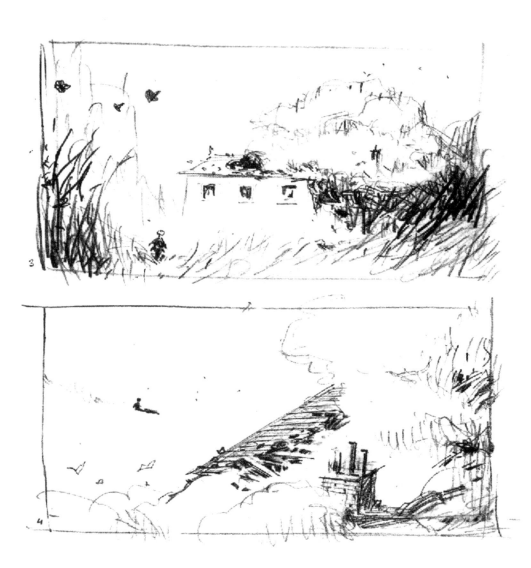

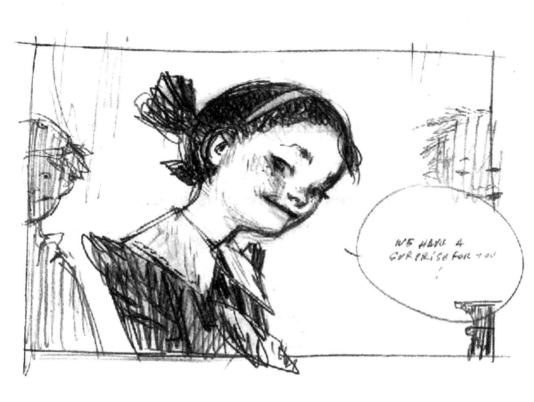

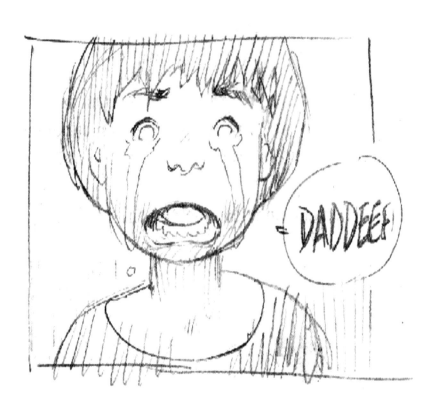

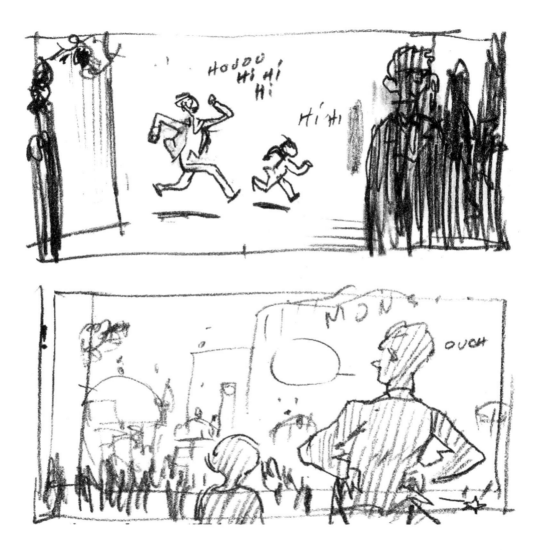

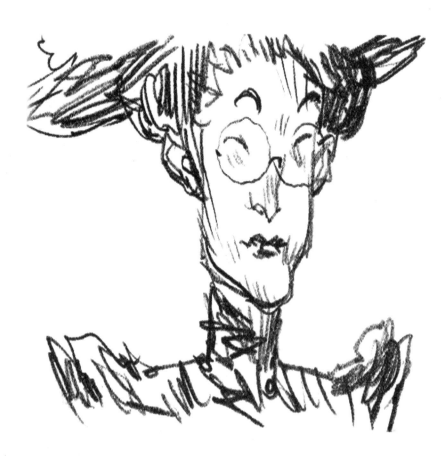

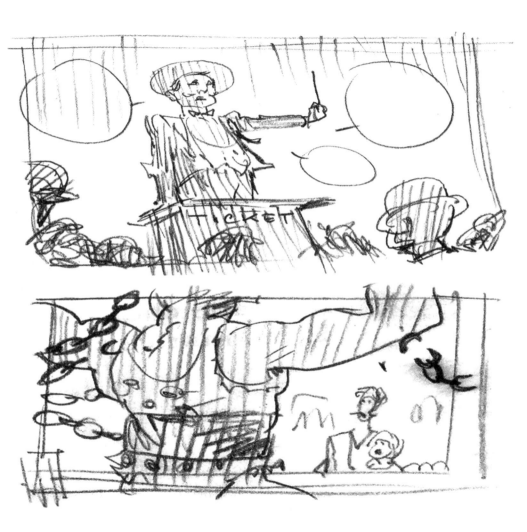

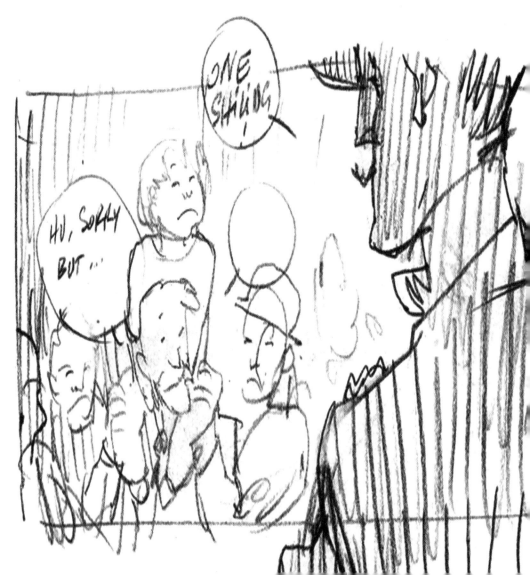

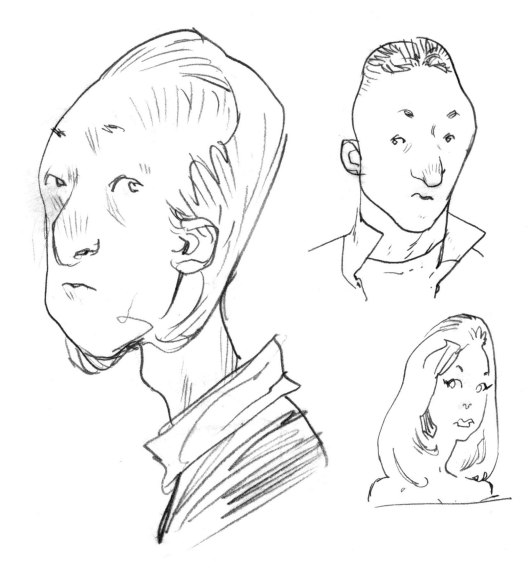

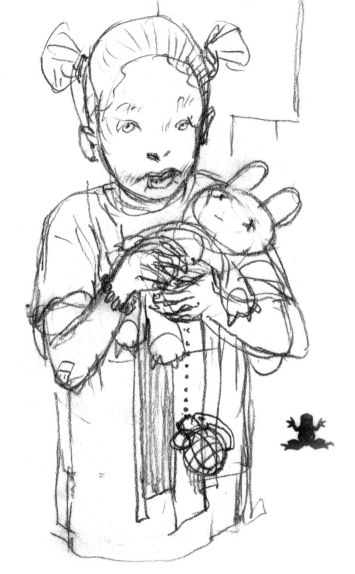

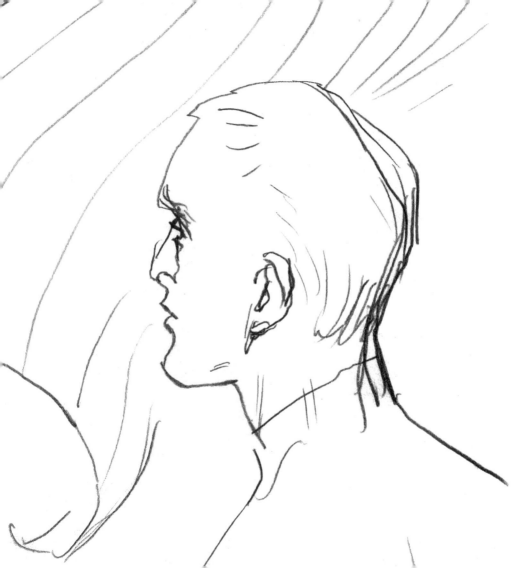

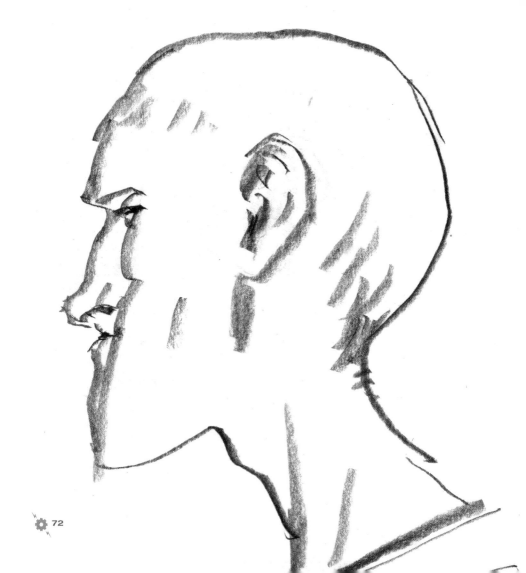

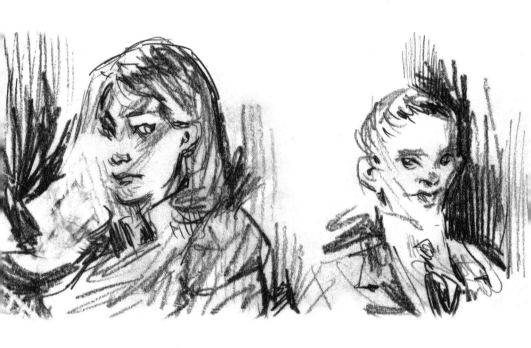

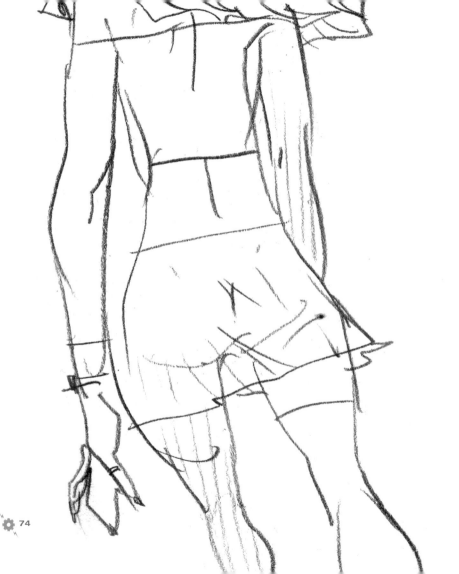

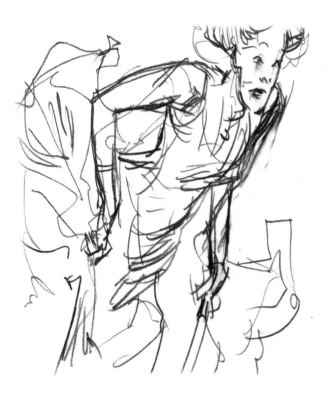

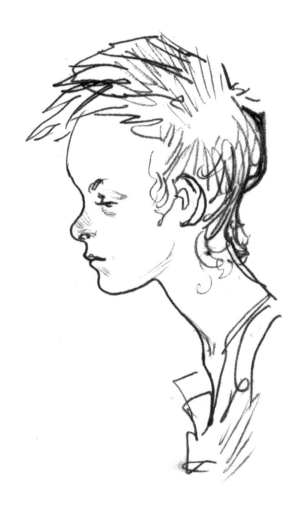

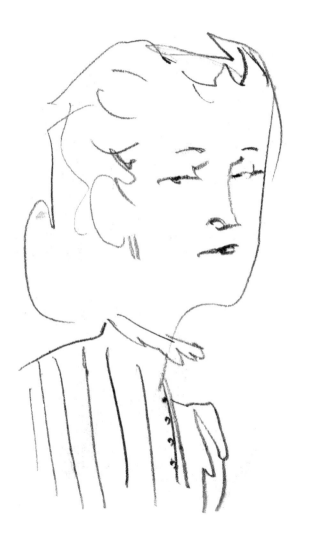

77 ☼

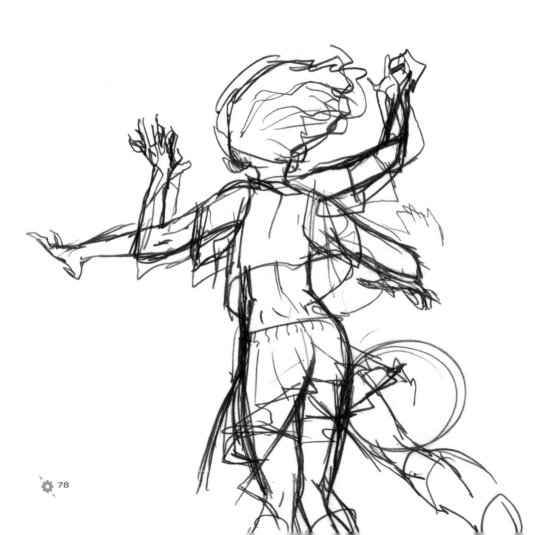

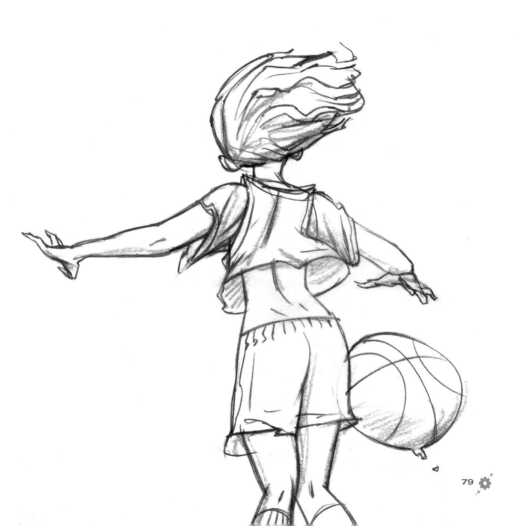

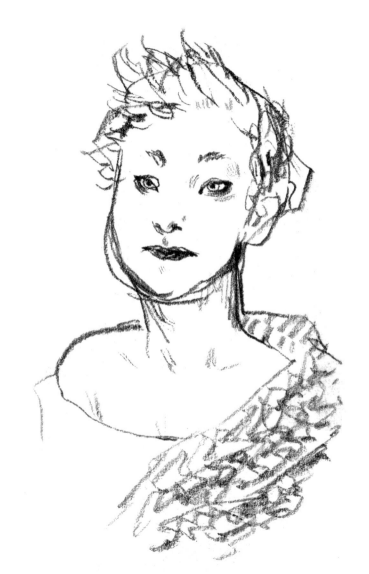

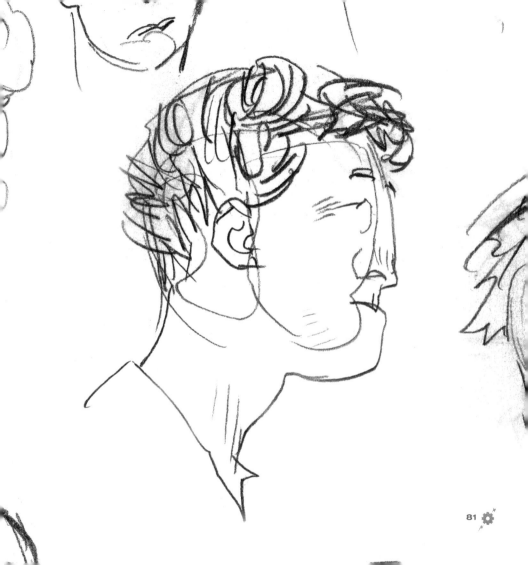

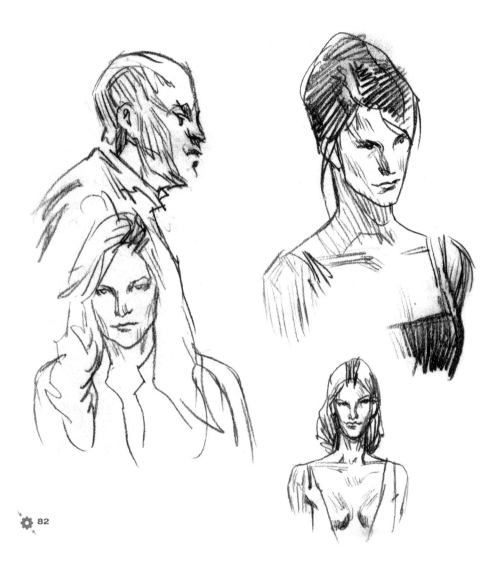

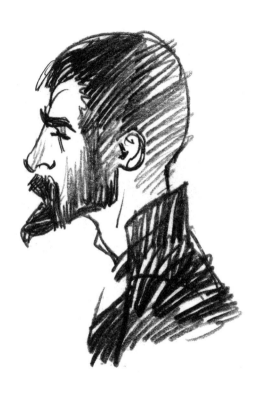

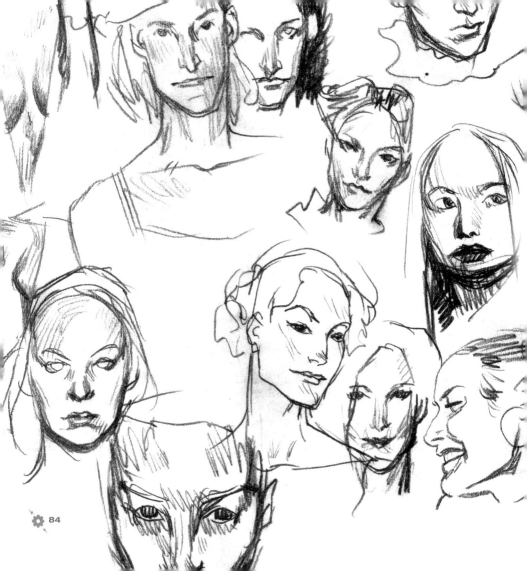

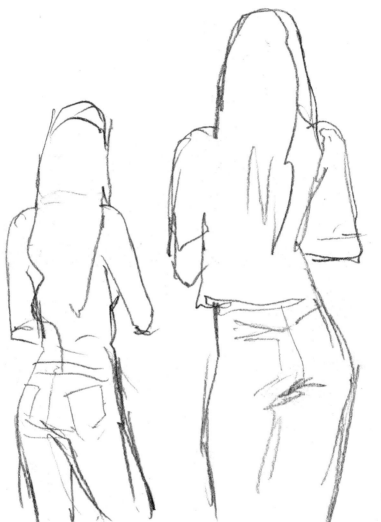

85

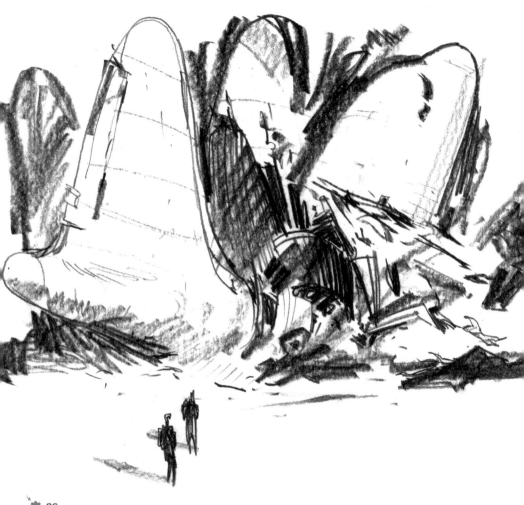

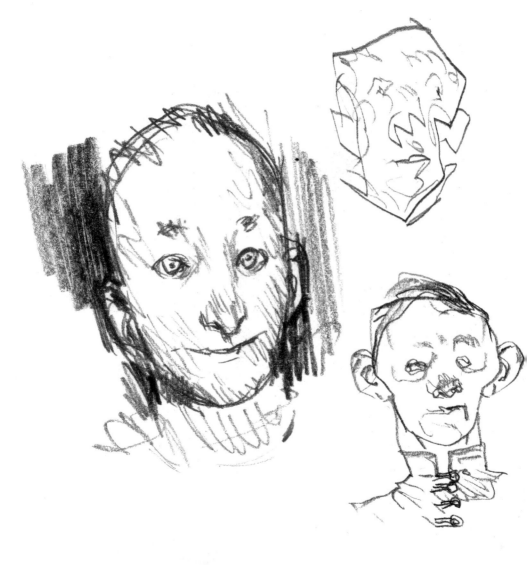

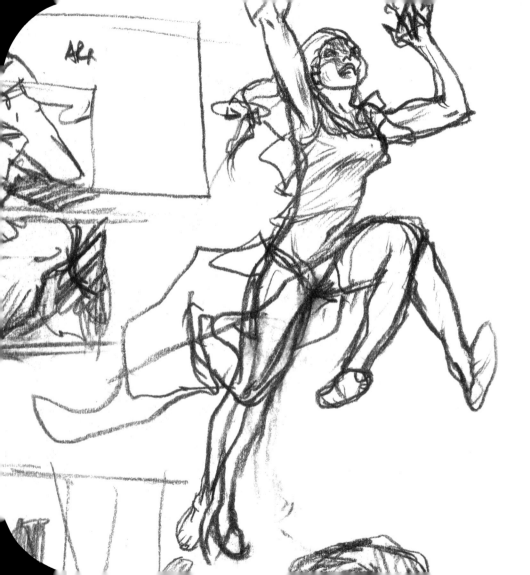

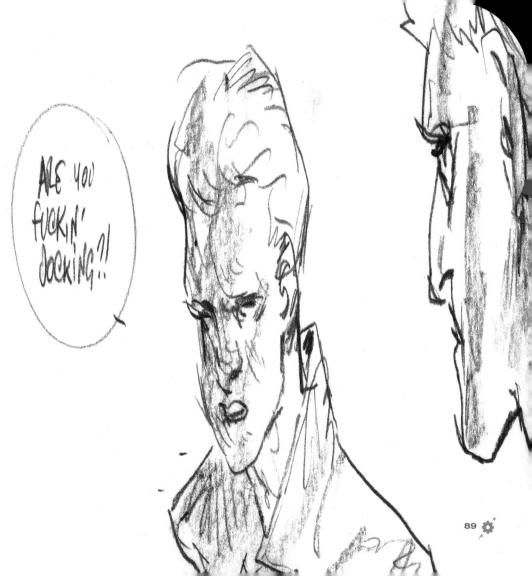

89

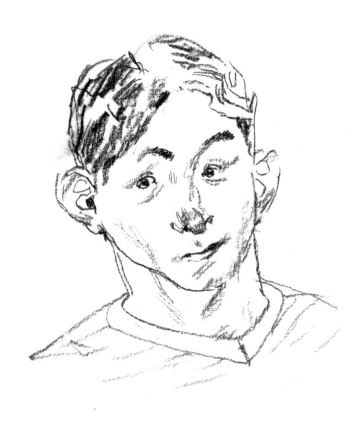

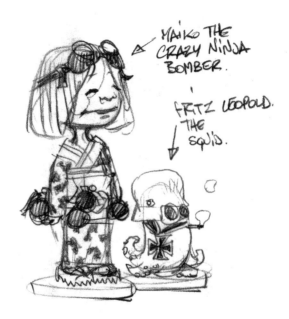

MAIKO THE CRAZY NINJA BOMBER.

FRITZ LEOPOLD. THE SQUID.

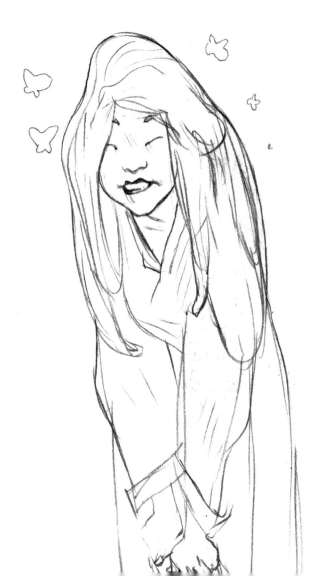

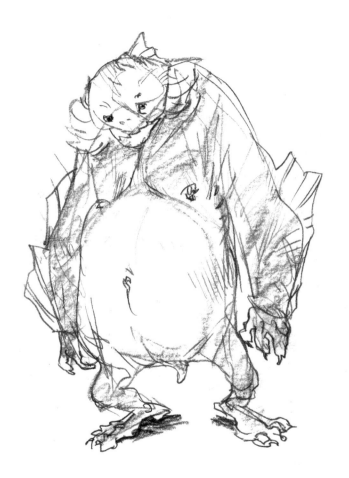

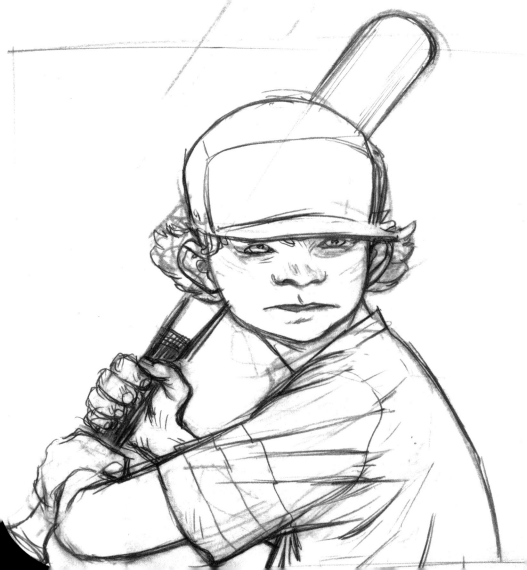

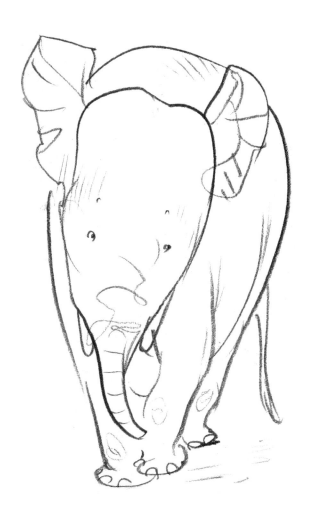

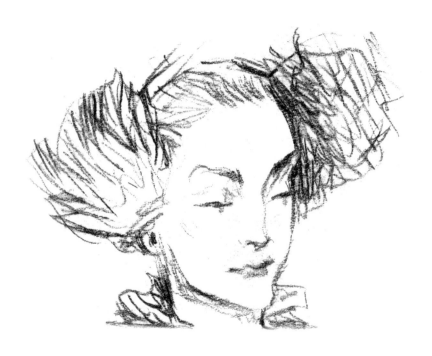

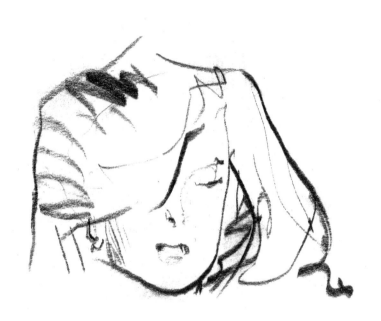

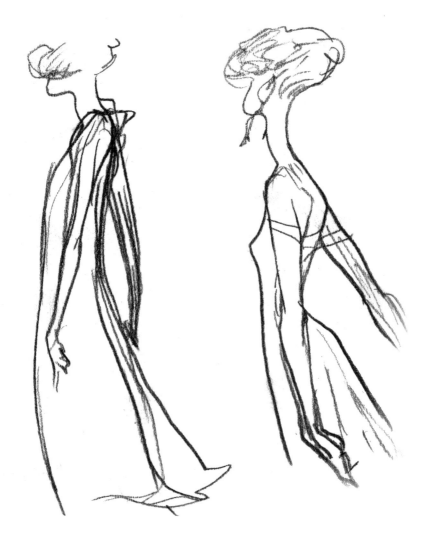

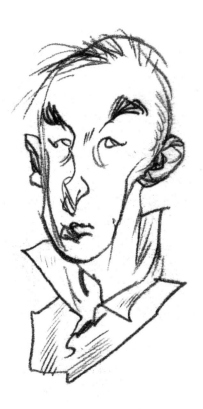

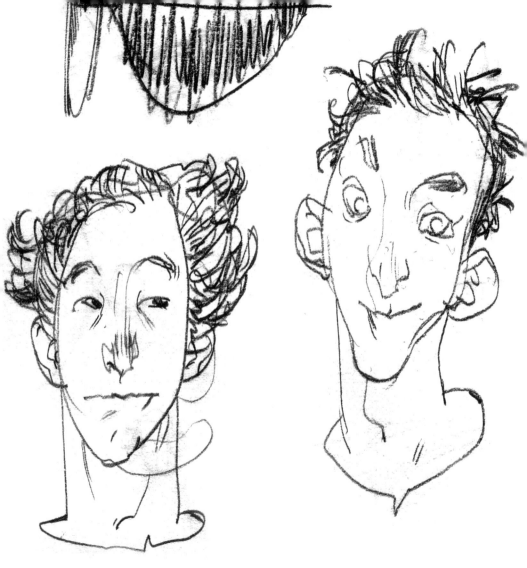

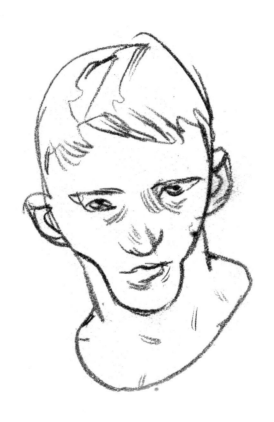

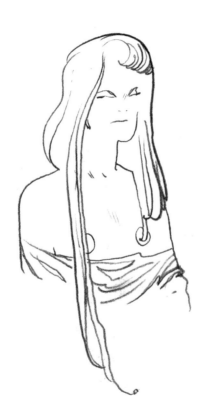

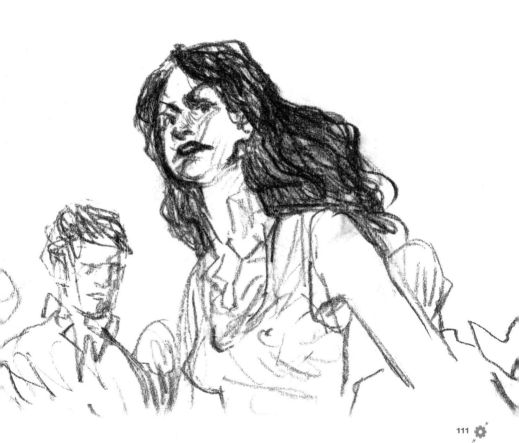

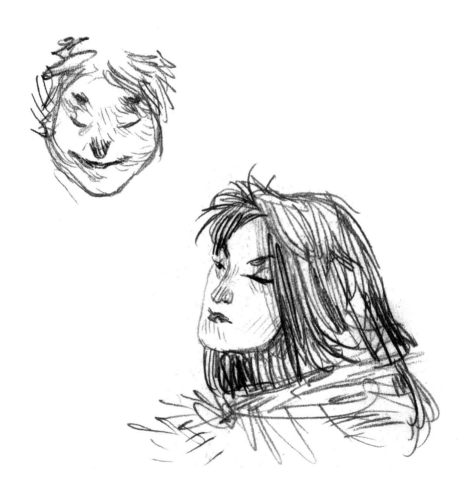

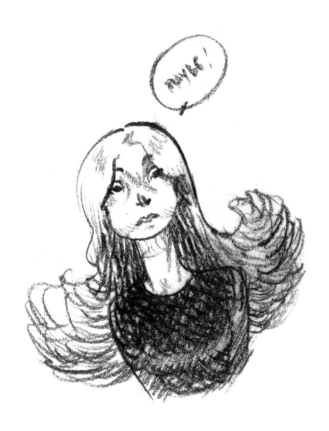

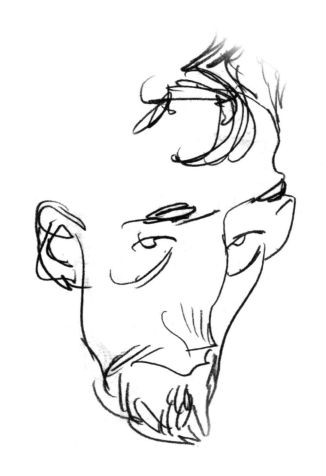

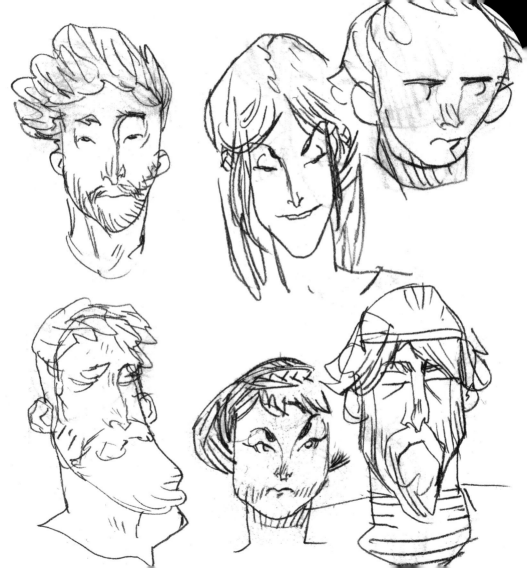

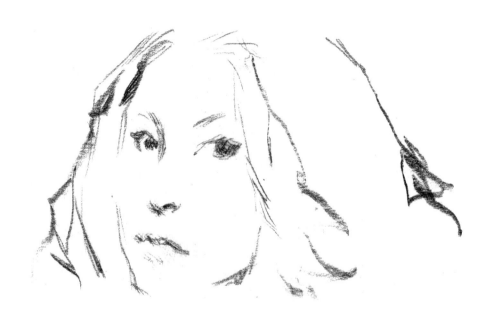

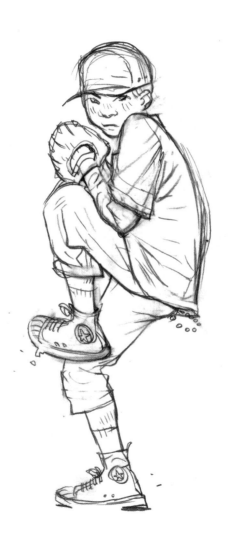

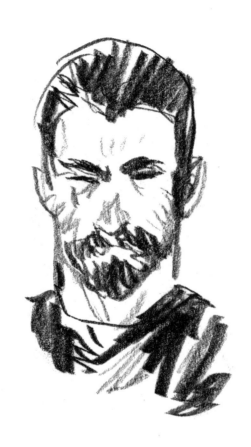

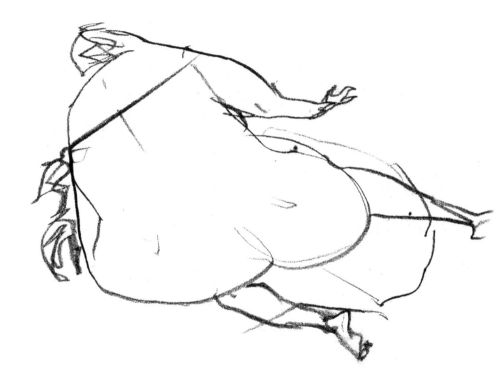

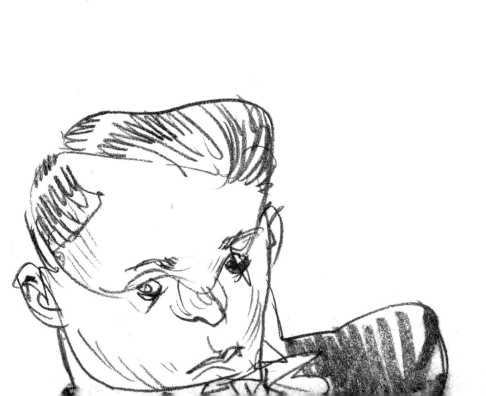

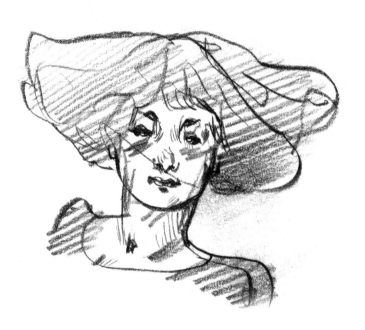

OOLONG DE FORMOSE

OOLONG DE FORMOSE

LOGOTYPE
of THE
SECRET
POLICE.

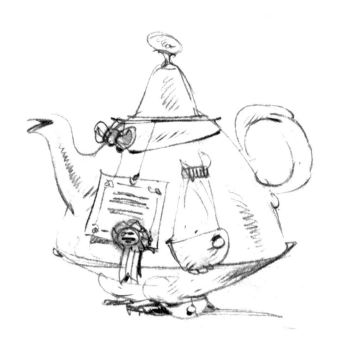

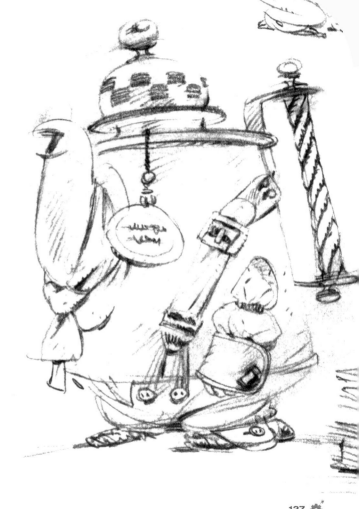

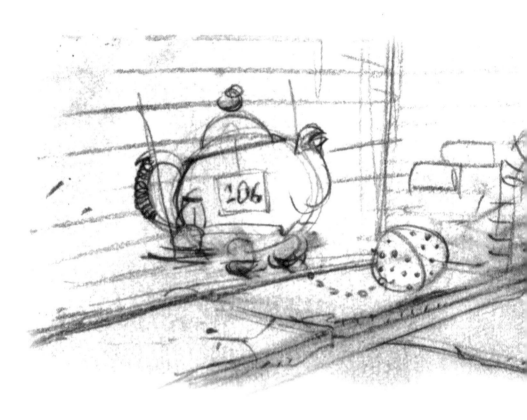

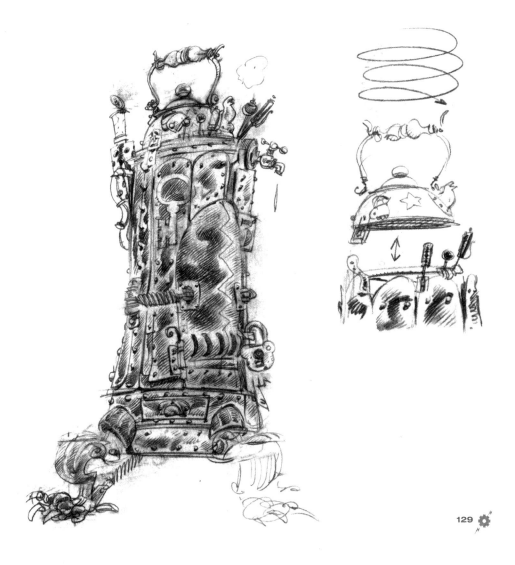

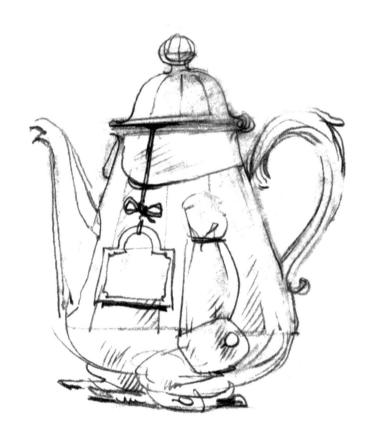

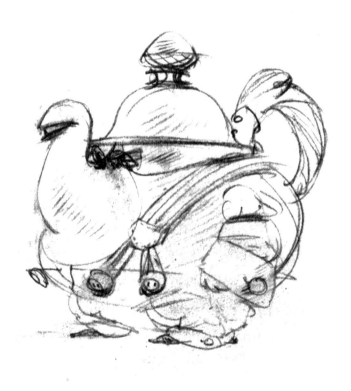

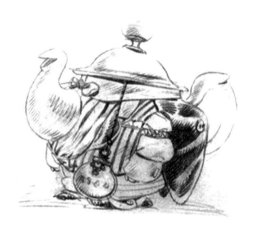

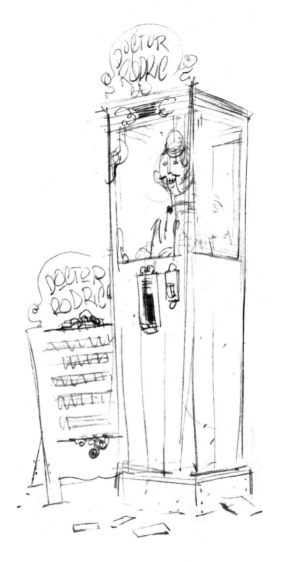

133

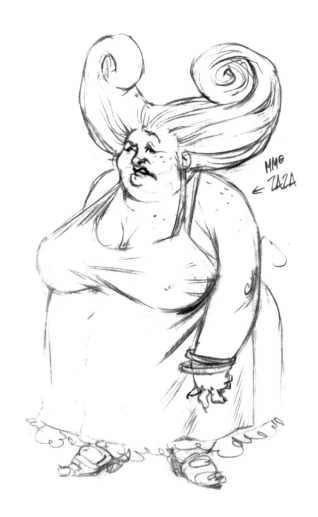

MME
← ZAZA

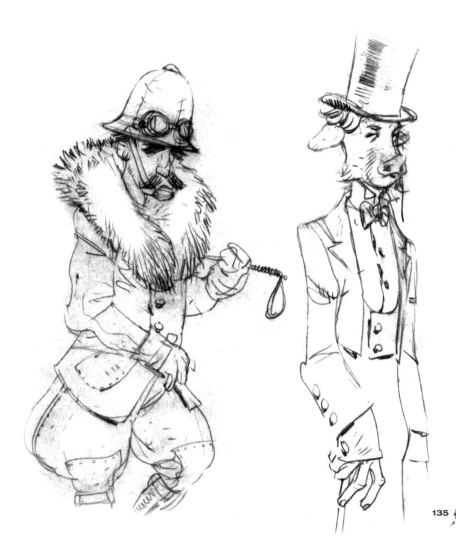

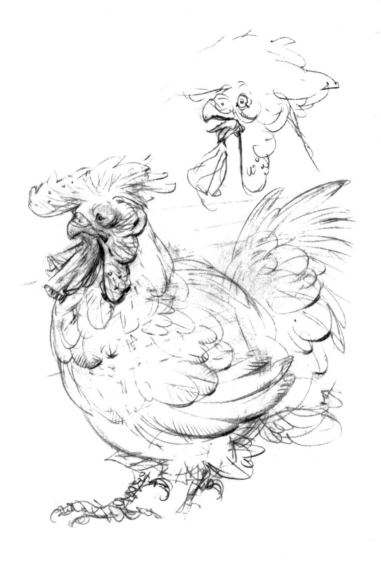

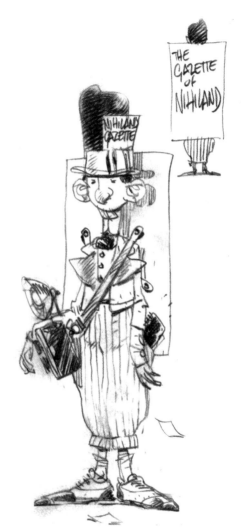

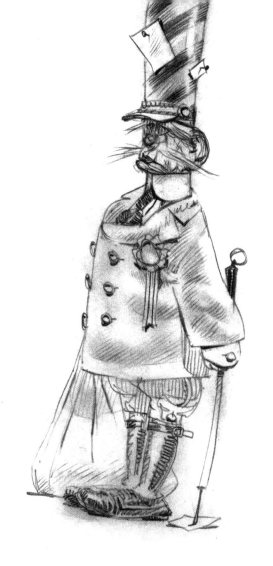

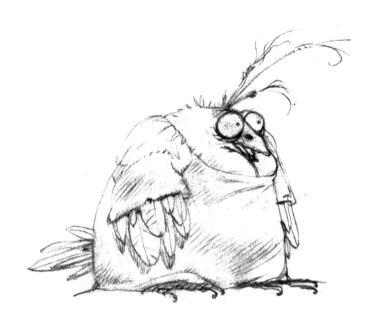

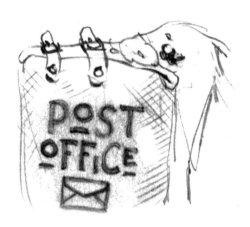

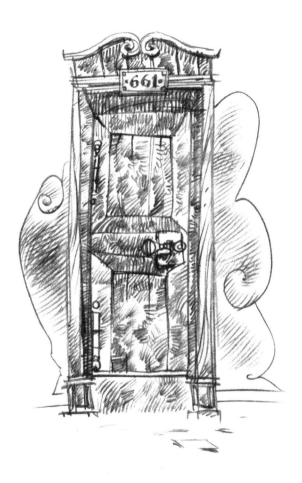

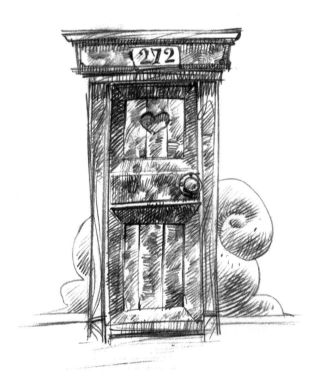

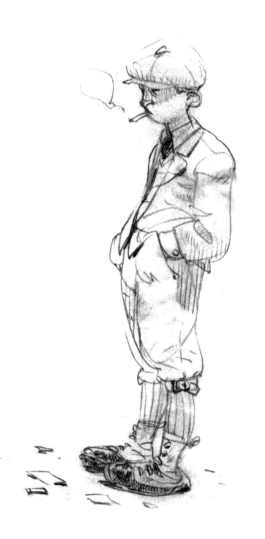

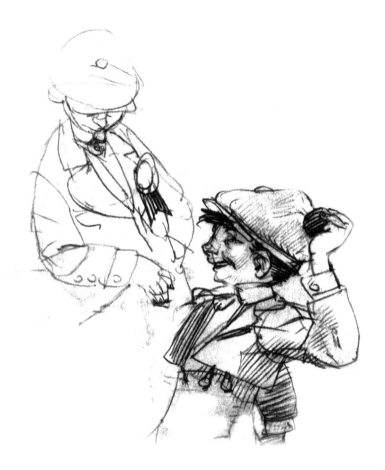

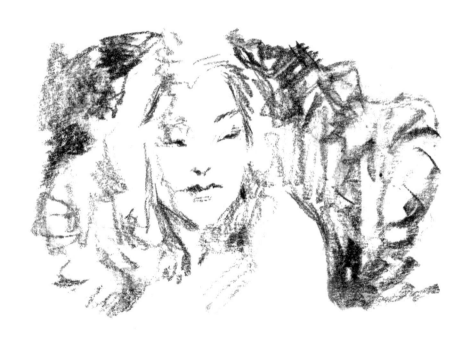

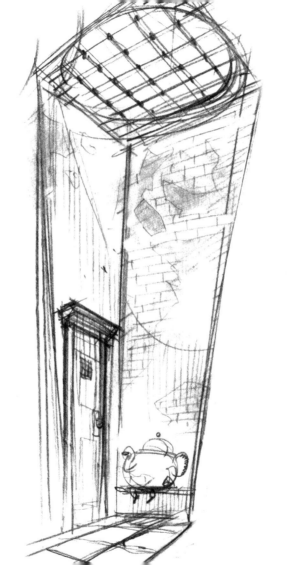

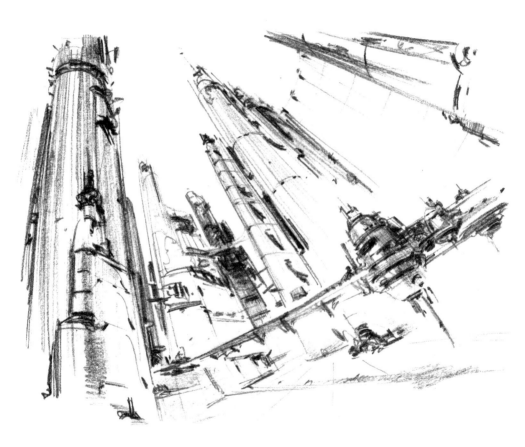

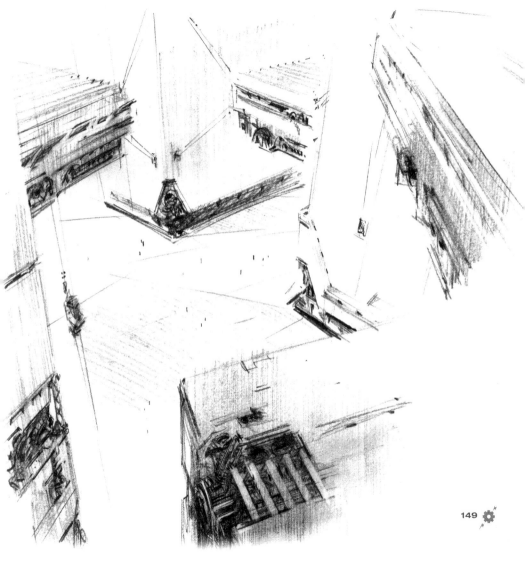

149

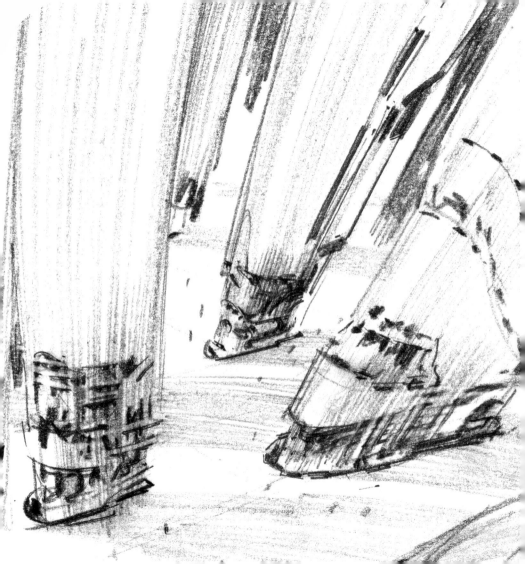

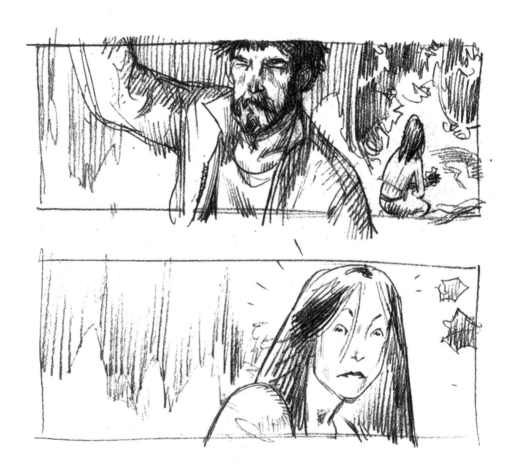

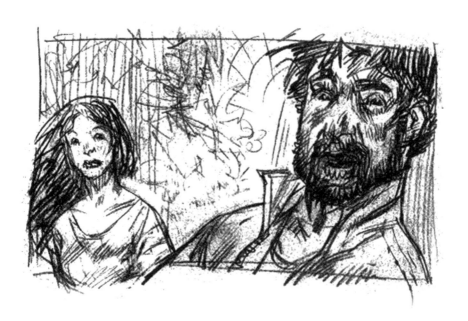

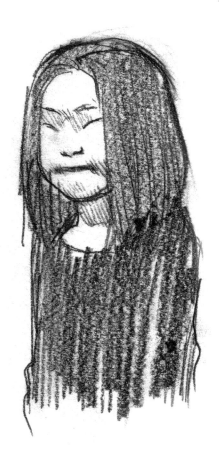

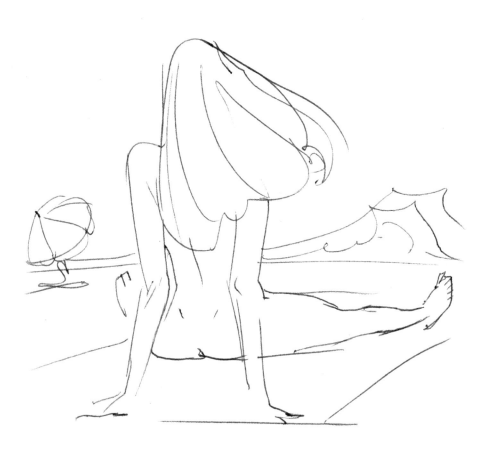

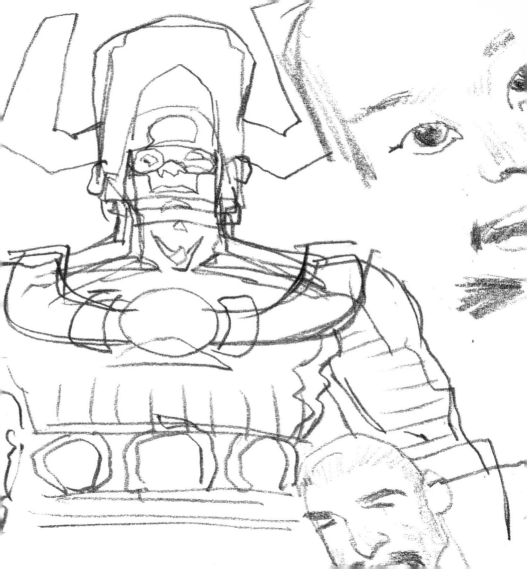

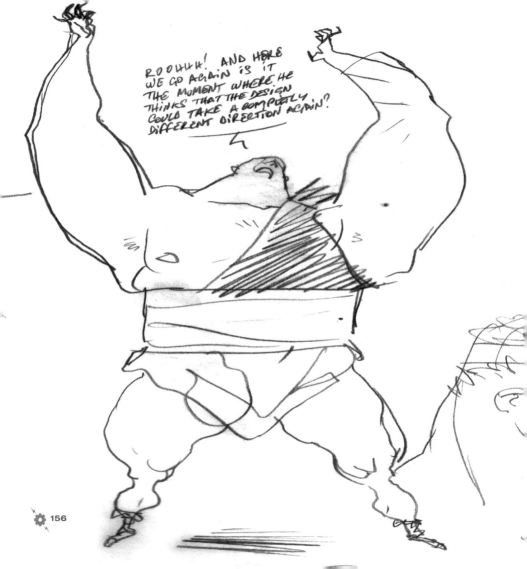

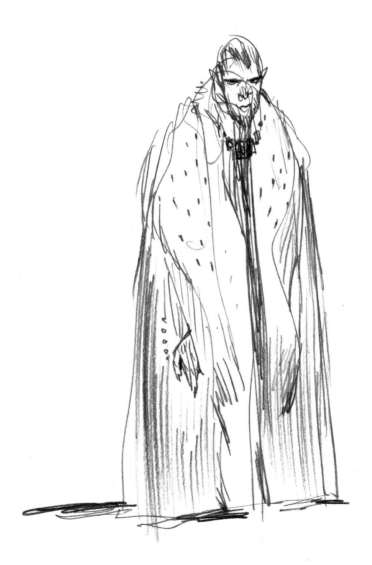

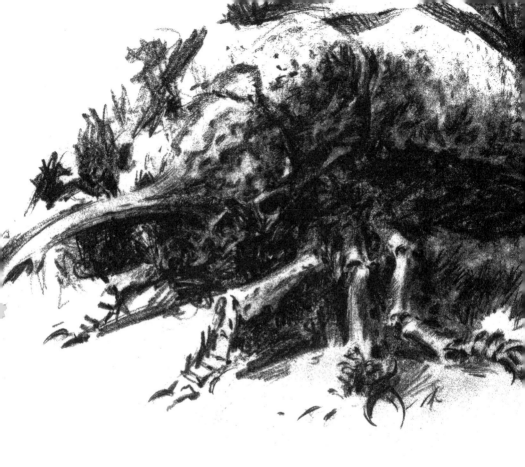

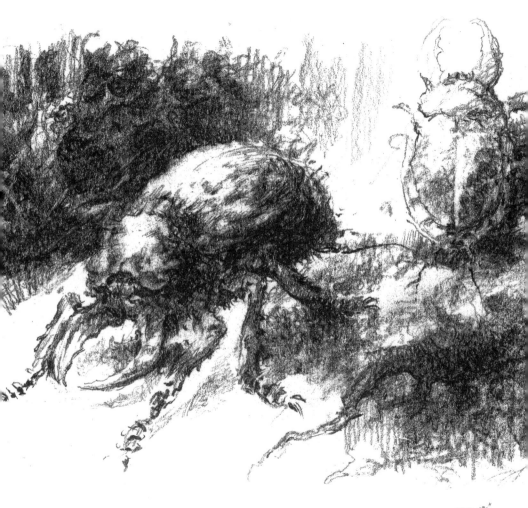

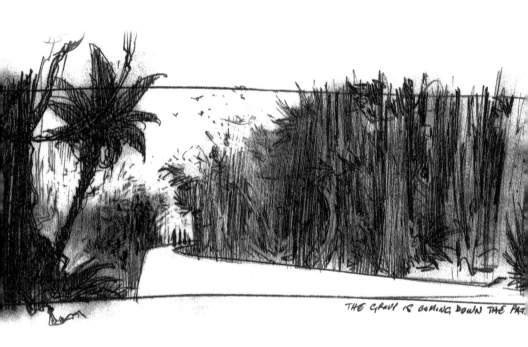

THE GROUP IS COMING DOWN THE PATH.

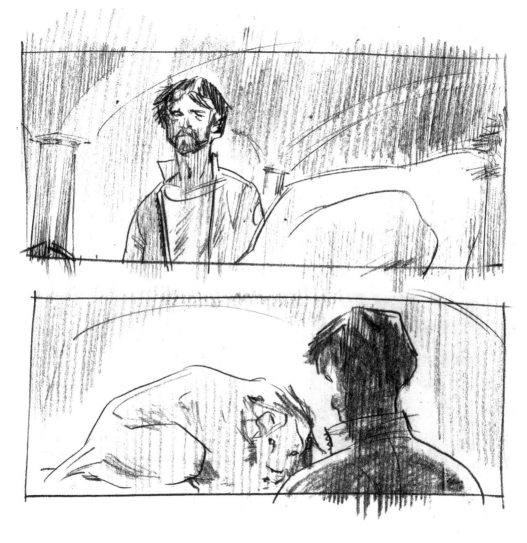

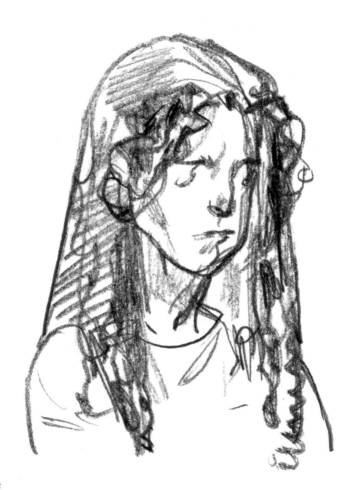

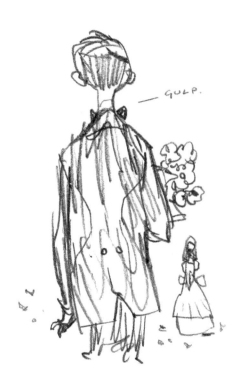

GULP.

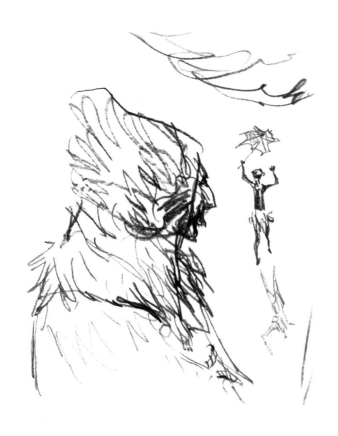

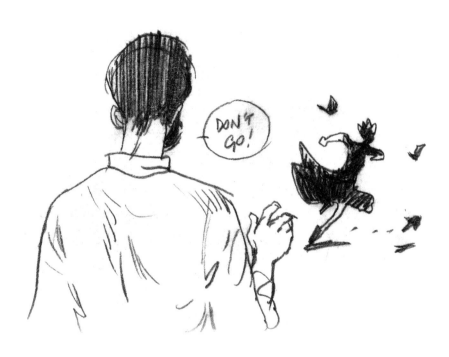

YEAH!

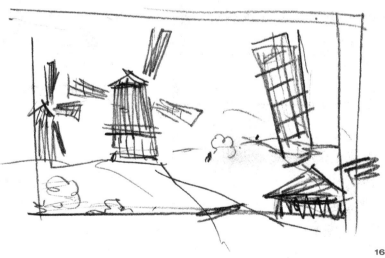

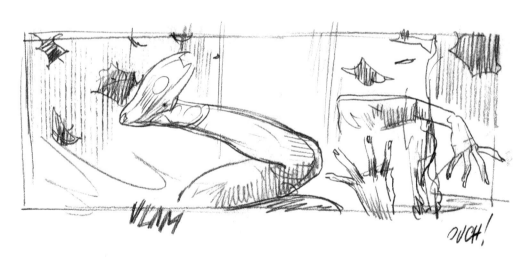

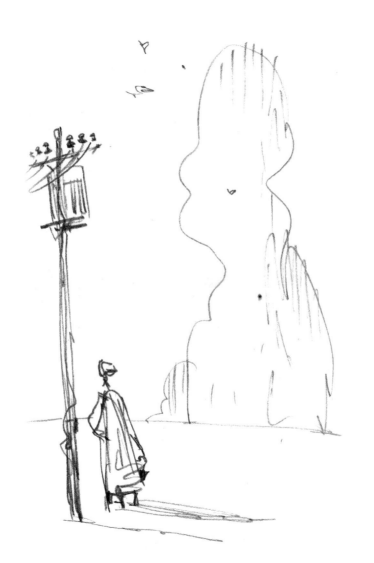

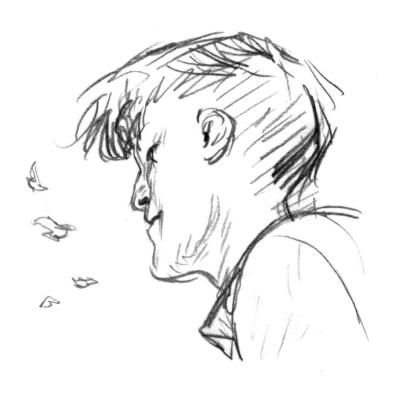

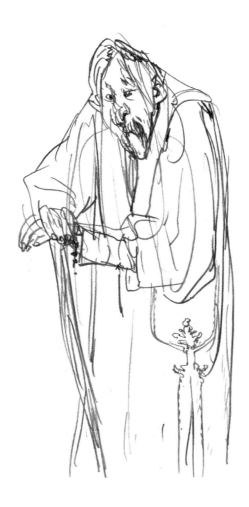

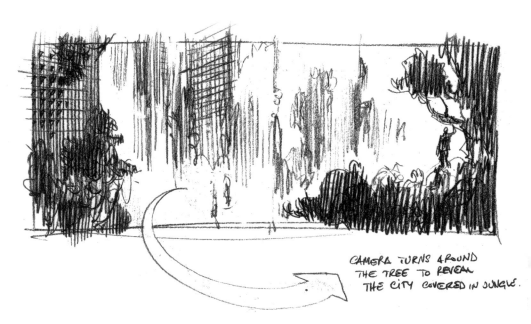

CAMERA TURNS AROUND
THE TREE TO REVEAL
THE CITY COVERED IN JUNGLE.

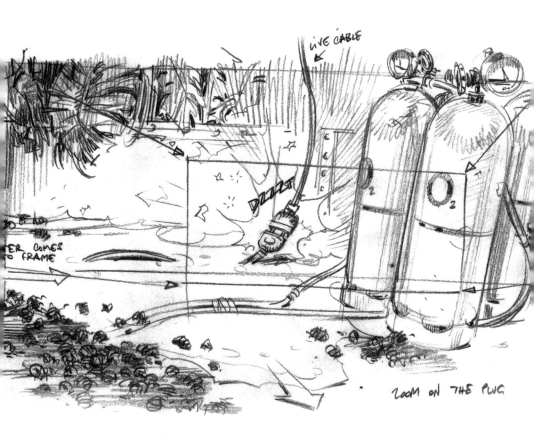

LIVE CABLE

DZZZT!

ER COMES
O FRAME

ZOOM ON THE PLUG

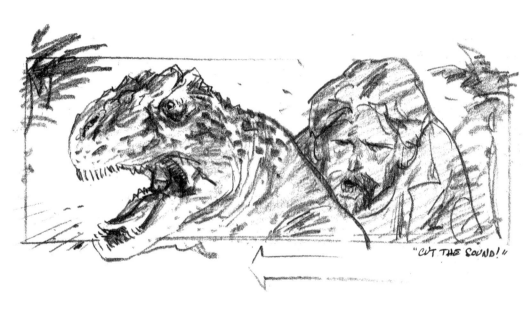

"CUT THE SOUND!"

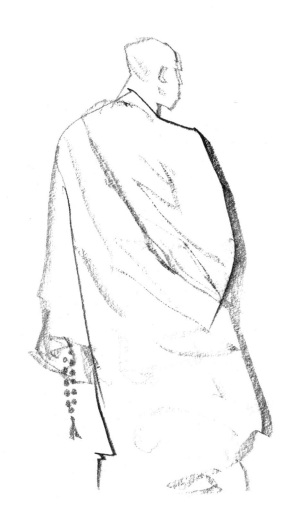

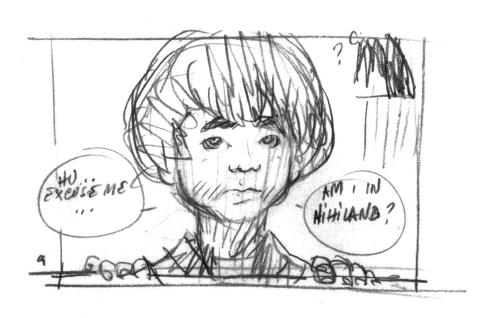

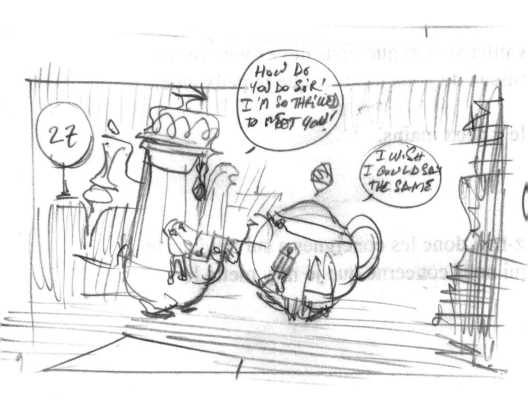

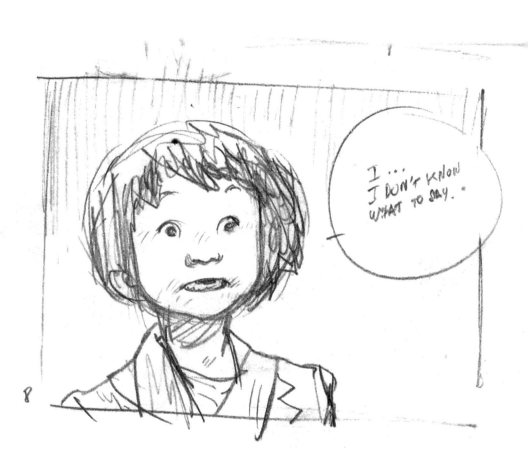

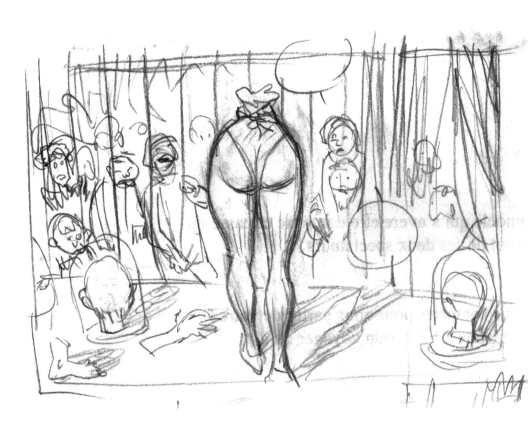

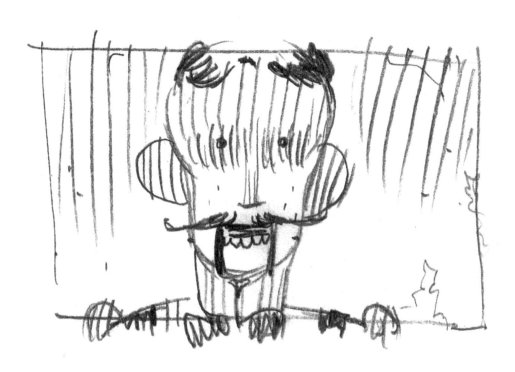

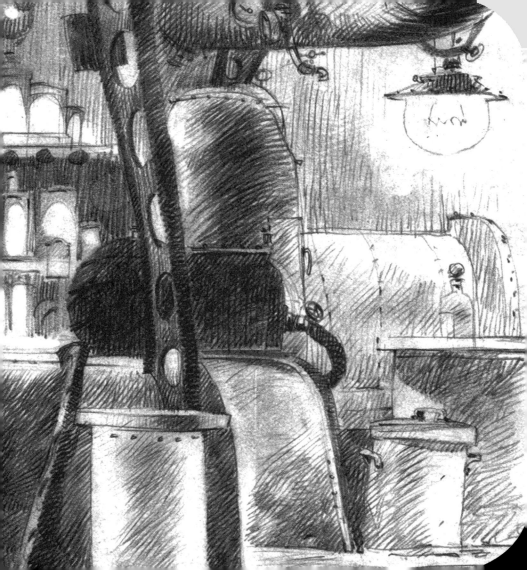

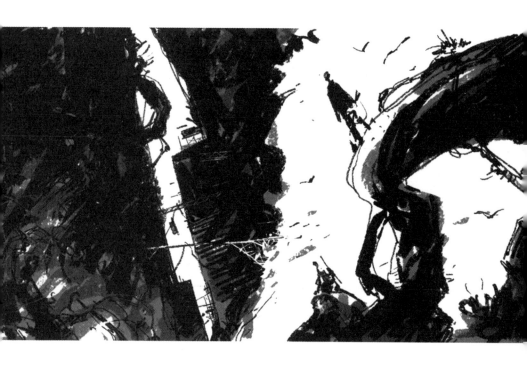

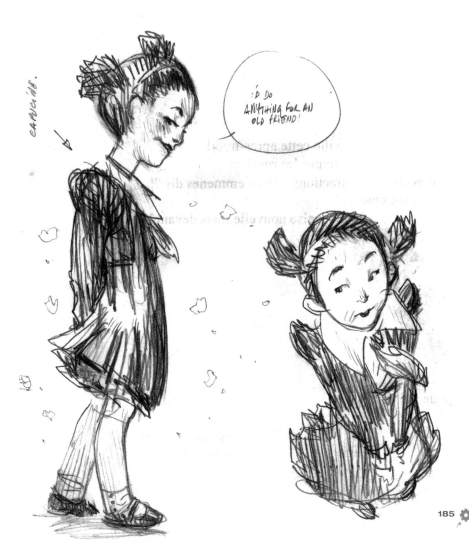

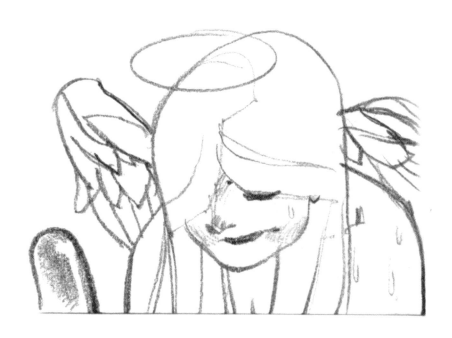

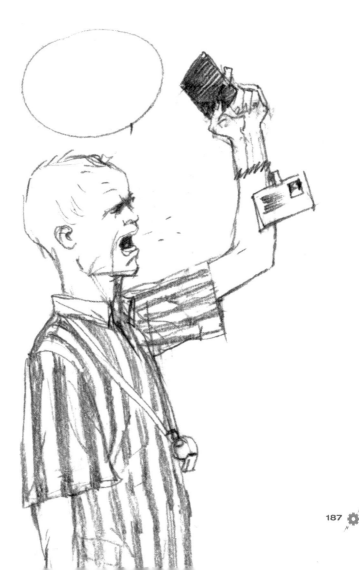

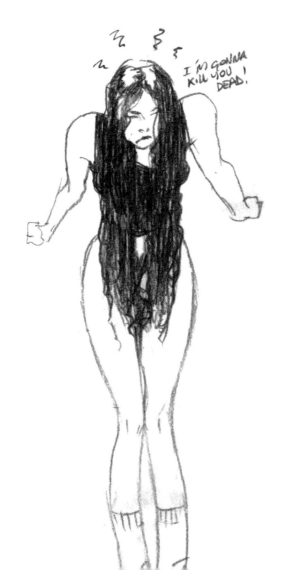

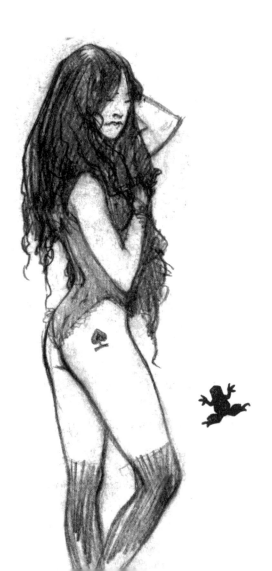

GRR

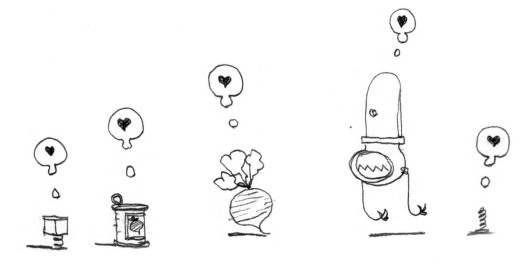

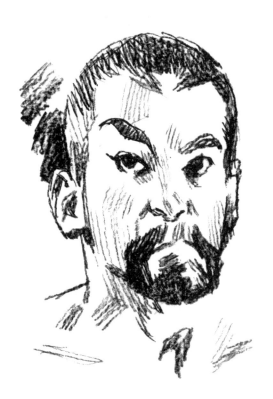

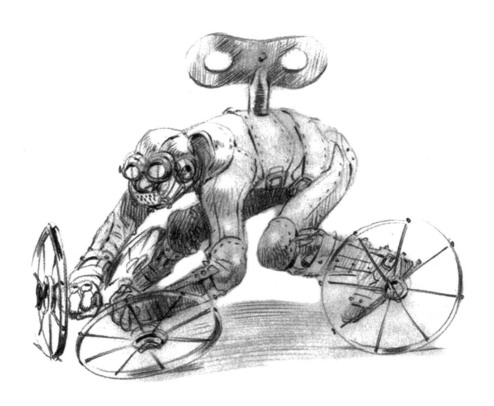

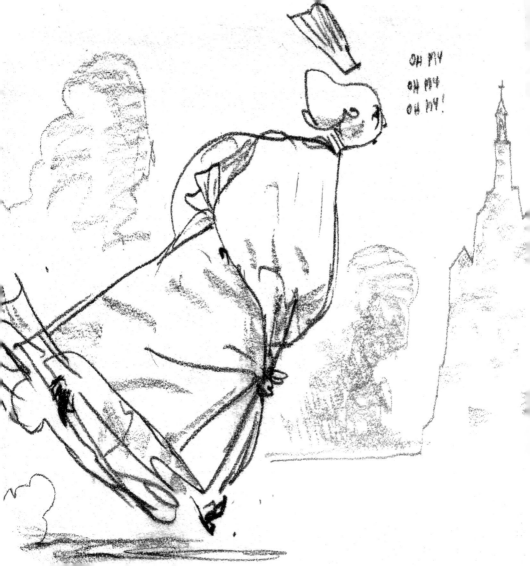

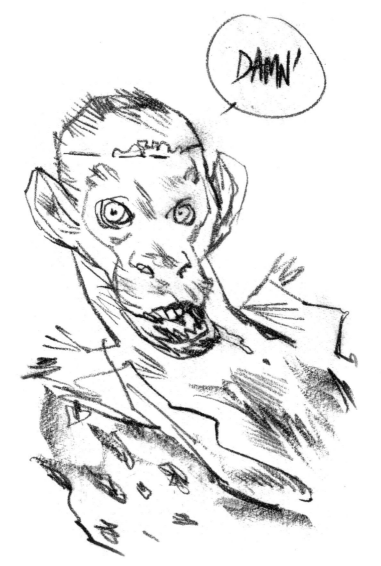

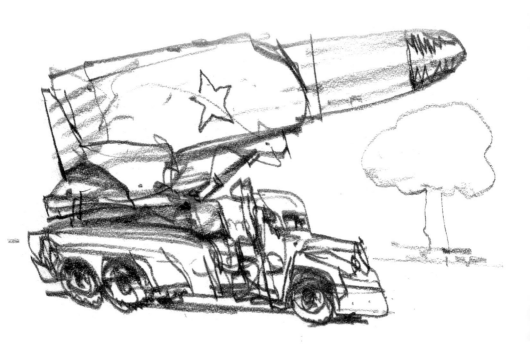

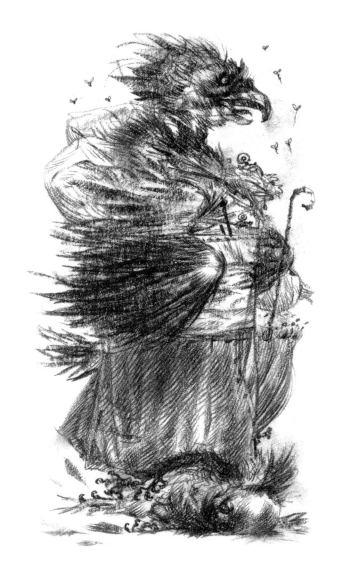

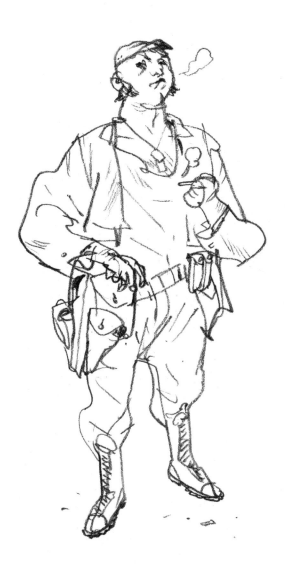

other titles by design studio press:

Lift Off:
air vehicle sketches & renderings
from the drawthrough collection
paperback ISBN-10: 1-9334-9215-5
paperback ISBN-13: 978-1-933492-15-5
hardcover ISBN-10: 1-9334-9216-3
hardcover ISBN-13: 978-1-933492-16-2

Start Your Engines:
surface vehicle sketches & renderings
from the drawthrough collection
paperback ISBN-10: 1-9334-9213-9
paperback ISBN-13: 978-1-933492-13-1
hardcover ISBN-10: 1-9334-9214-7
hardcover ISBN-13: 978-1-933492-14-8

Concept Design 2:
paperback ISBN: 1-9334-9202-3
hardcover ISBN: 1-9334-9203-1

Concept Design 1.5: revised edition
paperback ISBN: 1-9334-9245-7
hardcover ISBN: 1-9334-9246-5

Daphne 01: the art of daphne yap
paperback ISBN: 1-9334-9209-0
hardcover ISBN 1-9334-9208-2

LA/SF: a sketchbook from california
hardcover ISBN: 1-9334-9210-4

Luminair: techniques of digital painting from life
hardcover ISBN: 1-9334-9210-4

Entropia:
a collection of unusually rare stamps
hardcover ISBN: 1-933492-04-X

Worlds: a mission of discovery
hardcover ISBN: 0-9726-6769-5

AVP: the creature effects of ADI
paperback ISBN: 0-9726-6765-2
hardcover ISBN: 0-9726-6766-0

The Art of Darkwatch:
paperback ISBN: 1-9334-9201-5
hardcover ISBN: 1-9334-9200-7

The Skillful Huntsman:
paperback ISBN 0-9726-6764-4
hardcover ISBN 0-9726-6768-7

Monstruo: the art of carlos huante
paperback ISBN: 0-9726-6762-8
hardcover ISBN: 0-9726-6763-6

Mas Creaturas:
monstruo addendum
paperback ISBN: 1-9334-9207-4
hardcover ISBN 1-9334-9206-6

Quantum Dreams:
the art of stephan martinière
paperback ISBN: 0-9726-6767-9

Quantumscapes:
the art of stephan martinière
paperback ISBN: 978-1-933492-51-3

To order additional copies of this book and
to view other books we offer, please visit:
www.designstudiopress.com

For volume purchases and resale
inquiries please e-mail:
info@designstudiopress.com

Or you can write to:
**Design Studio Press
8577 Higuera Street
Culver City, CA 90232**
tel 310.836.3116
fax 310.836.1136